IMAGES
of America

THE LAPEER AREA

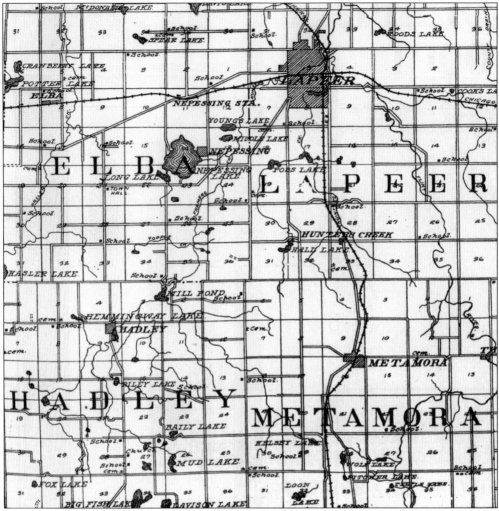

This map of the Lapeer area shows the location of Lapeer, Elba, Hadley, and Metamora. Farmers Creek was first an early settlement in Metamora Township; however, it was given up to Hadley Township around the 1870s. The banks along Nepessing Lake were home to a powerful tribe of the Chippewa Indians, the Nepessings. It consisted of 300 members who lived and planted maize and orchards along the banks of Nepessing Lake.

On the cover: The fluted columns of this Greek Revival seat of justice are seen clearly in this picture of the Lapeer Courthouse, which creates an elegant backdrop for the 58 members of the Knights of Columbus, Lapeer Council No. 1987. The council was instituted on June 1, 1919, and continued in existence until May 31, 1945, whereby, by action of the board of directors, it was dissolved. (Courtesy of Joseph Stock.)

IMAGES
of America

THE LAPEER AREA

Catherine Ulrich Brakefield

ARCADIA
PUBLISHING

Published by Arcadia Publishing
Charleston SC, Chicago IL, Portsmouth NH, San Francisco CA

Printed in the United States of America

Library of Congress Catalog Card Number: 2006930981

For all general information contact Arcadia Publishing at:
Telephone 843-853-2070
Fax 843-853-0044
E-mail sales@arcadiapublishing.com
For customer service and orders:
Toll-Free 1-888-313-2665

Visit us on the Internet at www.arcadiapublishing.com

*This book is dedicated to preserving the history of the people
and events that comprised the early years of the Lapeer area for this
generation and for future generations to learn from.*

CONTENTS

ACKNOWLEDGMENTS

I am grateful to those individuals who willingly donated their pictures, knowledge, and experiences, for this book would not have been possible without their support.

I wish to thank Bill Rykhus, president of the Lapeer County Historical Society (LCHS), for his support and encouragement in making this book a part of the Lapeer heritage and Don and Pat McCallum for the pictures and reference materials they generously provided me.

Kent and Reta Copeman of the Hadley Township Historical Society provided pictures, stories, and a countless amount of encouragement.

A special thanks to Betty de Angeli for her support and encouragement and to the Marguerite de Angeli Library, WMPC general manager Bob Baldwin, who always found time out of his busy schedule for me, Jack McCauley, principal of the Chatfield School, Renee Pearson of the First Presbyterian Church, and Sue Vaughn of the Immaculate Conception Church for their endless knowledge and assistance.

My utmost respect and admiration goes to Ellen Williams, whose ready smile and memories of Lapeer were priceless. Her volunteer work at the library and historical society categorizing photographs and newspaper clippings provided me with an untold wealth of information, facts, dates, and history not found within the pages of a book.

There are several authors who helped pave the way toward the factual information attained for this book: *Pioneer Families and History of Lapeer County, Michigan* by J. Dee Ellis, *The Historical Scrapbook of Hadley Township* by the Hadley Friends of the Library, and *Metamora Among the Hills* by the Metamora Friends of the Library, *Butter at the Old Price* by Marguerite de Angeli, *Michigan's Marguerite de Angeli: The Story of Lapeer's Native Author-Illustrator* by William Anderson, *Squabble City* by Russell B. Franzen, *Life at Greene's Corners* by Clarence W. Greene, *100 Years of the Catholic Church in Lapeer* by Immaculate Conception Church, and *The Addison Album* by Barbara D. Stafford. Further reference materials used were from the *Lapeer County Press* newspaper and Ziibiwing Center.

I also wish to thank my editor, Anna Wilson, and my publisher, John Pearson, for their patience and professionalism. Their reassurance provided me with an endless wave of motivation.

Most importantly, I want to thank my husband, Edward Brakefield, for his constant support, my son, Derek Brakefield, for his never tiring ear, my daughter, Kimberly Warstler, for her encouragement and her helpful ideas in how to make this book interesting for people outside the Lapeer area, and my two grandchildren, Zander and Logan Warstler, our future generation of readers whom this book will enlighten into a part of history not often read about within the pages of a history book.

INTRODUCTION

In the early summer months of 1831, the vast forests along the Flint River called La Pierre beckoned to two brothers from New York, Alvin Nelson and Oliver Hart, to explore the area. In November of that same year, Alvin Nelson Hart brought his family, brother-in-law George Ball, Joel Palmer, and Joseph Catout to the area to settle. Oliver Hart would arrive later. The second settlers to appear were a group lead by Jonathon R. White and others soon followed. Tough and resilient, these families of Puritan and New England stock came with dogmatic determination to tame the primitive regions of this new wilderness that Hart named Lapeer. Lapeer would later become the name to officiate a new county on February 2, 1835, which would eventually consist of 18 townships, seven villages, and two cities.

In spite of deprivation, sickness, isolation, smallpox, and influenza, these early settlers stubbornly accepted their circumstances with good humor and perseverance. Long-established names like Hart, White, Tuttle, and Lofft have reared generations here who have become farmers, doctors, lawyers, sheriffs, and politicians. Many residents worked at Lapeer's railroads, foundries, churches, and the Lapeer State Home and Training School, an asylum for the feebleminded and epileptics, became the largest facility of its kind in the state and one of the largest in the nation.

In this pictorial journey of the Lapeer area, you will learn about the staunch dedication and determination of the people. Even the bitter rivalry between the Hart and the White families, which comprised two generations, produced a favorable outcome with many cultural advantages for the city. Although Lapeer was a village in 1833, both R. G. Hart and Henry K. White avidly worked together to encourage the incorporation of Lapeer as a city in 1869. While Whitesville no longer exists and the White family failed in achieving a permanent courthouse, Alvin Nelson Hart's courthouse still stands today as the oldest working courthouse in Michigan, and Henry K. White became one of the founders of the First National Bank of Lapeer.

Ingenuity, hard work, and a ready sense of humor turned the wilderness of woods and swampland into productive thoroughfares for prosperity. Flour mills and lumber mills, logging camps and countless farms, and two foundries and a factory kept the Flint River and Farmers Creek busy with products and produce. With the advent of the railroad, a second venue for markets increased productivity for farmers and businessman alike.

Although the growth of the Lapeer area was substantially slowed with the onset of the Civil War, men responded eagerly to the call to bear arms in an effort to reunite the states and free the Southern slaves. Many families and sweethearts faced the hardships of their menfolk's death both on the battlefield and in the prisons.

In April 1887, over 6,000 immigrants traveled through Lapeer on crowded trains to Wisconsin and the Dakotas. Then the train would stop just north of Nepessing Lake, which was then called Oaklet.

It took another 10 years for the newspapers to decide just how to spell that old Native American name that honored the Nepessing Indian, once a powerful and prosperous tribe who by the late 1800s had dwindled down to one, Chief Wau-be-ka-kuk (Gray Hawk). But that is yet another story that you will read about between the pages of this book.

Join me in this pictorial history of the Lapeer area and learn why a part of this 173-year-old city is still fondly remembered as Piety Hill.

One

EARLY YEARS

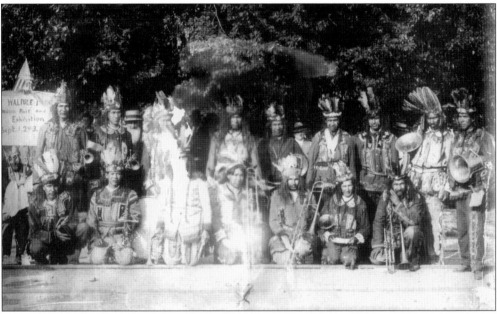

During one bitter winter, the Nepessings faced starvation when a smallpox epidemic weakened the tribe. Still convalescing, Chief Wau-Pe-Seng set out in full regalia to the neighboring village for help. He never made it. Halfway between the villages, his wampum belt, beads, and silver necklace were found, the only things the wolves had left. His son, Chief Pam-quong (Thunder Storm Passing), became the leader of the tribe, less than half in number. Around 1845, the Native Americans were moved to the reservation. Chief Pam-quong moved to the tribal village between Almont and the St. Clair River where Chief Wa-Wiah-Sum (Lightning) was born. Chief Lightning received the name William Chatfield from the Bradley missionaries in the mid-1800s. He passed away in March 1884, and his son, Chief Wau-be-ka-kuk (Gray Hawk), Peter Chatfield, became the last chief of the Nepessing tribe. Peter Chatfield is seen kneeling in the front row, middle, holding his trombone with the Chippewa Indians on Walpole Island. His mother, Weng-Be-Queh, was born on Walpole Island. (Courtesy of Deborah Smith Lawson.)

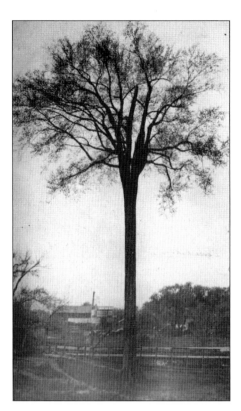

The Hart brothers used this tree as a landmark in the summer of 1831 during their first expedition into the uncharted regions of what is now Lapeer. They buried their burned-out coffeepot beneath the base of this elm tree, and the tree became a landmark and symbol of Lapeer's pioneering spirit for years to come. A plaque now marks the spot where the elm once stood. (Courtesy of Don and Pat McCallum.)

Although Alvin Nelson Hart named the new town Lapeer, Jonathon R. White platted Whitesville one month before Hart finalized his paperwork for Lapeer. Each relied on waterways to set their town's boundaries. The post office of the divided villages moved back and forth, depending upon who was the postmaster. The first post office was in Whitesville, at the home of Minor Turrill, the first postmaster. Twice a week mail was delivered to the Whitesville post office from Royal Oak through Orion. The carrier, a Mr. Rose, traveled on foot and then by horseback or buggy. This letter, from the Whitesville post office, is dated September 23, 1835. (Courtesy of the LCHS.)

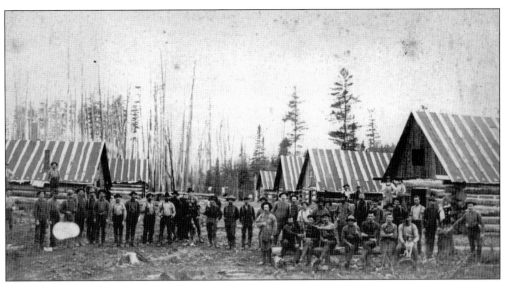

Quality white pine trees allowed the timber industry to thrive in Lapeer County. Lumber camps like this one sprung up overnight, and sawmills provided added industry and employment. (Courtesy of Ervin Haskill and the LCHS.)

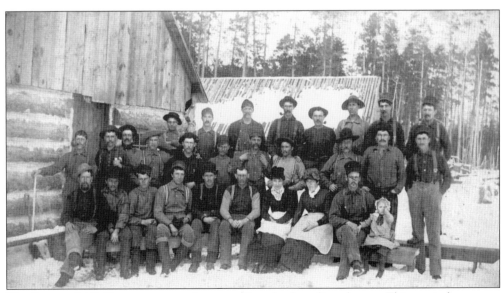

The Pontiac Mill Company erected a sawmill and a boarding shanty. This rustic house was managed by a Mrs. Potter. She is thought to be one of the first white women to live in Lapeer County. About two-thirds of Lapeer County laid covered in the bountiful natural resource of white pines. (Courtesy of Ervin Haskill and the LCHS.)

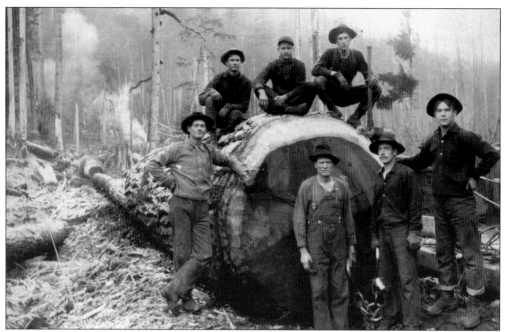

Lapeer had too few navigable rivers to float the vast forests of timber wood. Sawmills then had to be built close to large stands of trees. The log depicted in this photograph must have taken this crew of men many hours to saw down because the crew seems at a loss of what to do with this big log. (Courtesy of the LCHS).

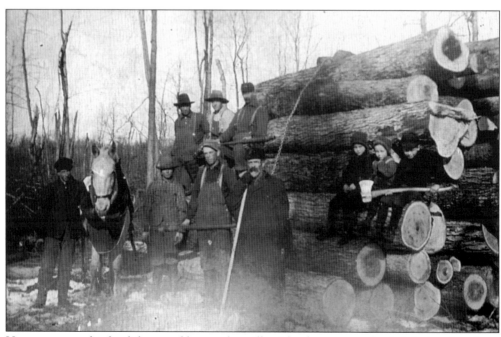

Horses were used to haul the sawed logs to the mills, either by wagon or by sled during the winter months. The lumbermen's families often followed their fathers and uncles from camp to camp. (Courtesy of the Davis family collection.)

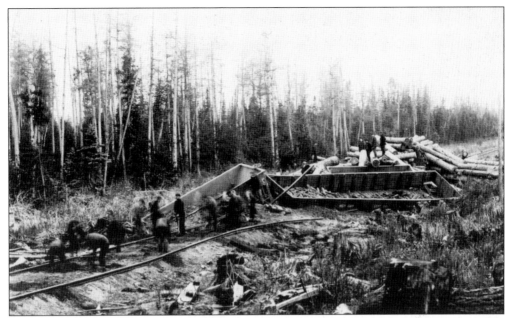

This railroad logging wreck occurred between Attica and Elk Lake, possibly in the late 1870s or early 1880s. Oftentimes the railroad was used to transport timbers. Despite mishaps, the lumbering industry in Lapeer continued to grow and so did the township's ever-increasing population during the 1800s. (Courtesy of G. W. Topham and the LCHS.)

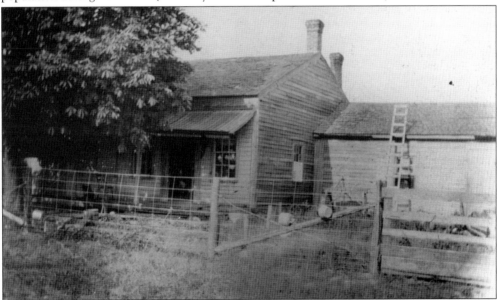

Just south of Lapeer lies what is now known as Hunters Creek. This is a picture of Clarks' Corners Hotel, which was built in 1849 and used as an overnight stop for transients. This photograph was taken from the album of Mrs. James Cathers, whose husband was buried in 1846 in Farmers Creek Cemetery. The implement sitting in the corner, just left of the ladder, was a tool used to sharpen crosscut saws, and the wire fence in front of the house kept the chickens from wandering down the street. The widow and her family moved to California several years later. (Courtesy of Mrs. James Cathers and the LCHS.)

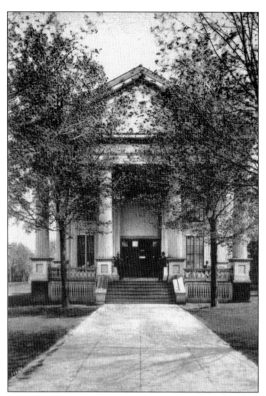

The courthouse feud began when Alvin Nelson Hart, a Democrat, and Henry K. White, a Whig, both built a courthouse for Lapeer. Hart built his on Nepessing Street and White in Whitesville. Whitesville was located at what is now South Main Street, north of the creek to DeMill Road. Lapeer began at the creek to the south, and the river was its eastern boundary. The board of supervisors decided upon Hart's courthouse in 1853. This is a 1907 picture of that courthouse with Loren Elliott (left) and John Conley standing upon the courthouse steps. (Courtesy of the LCHS.)

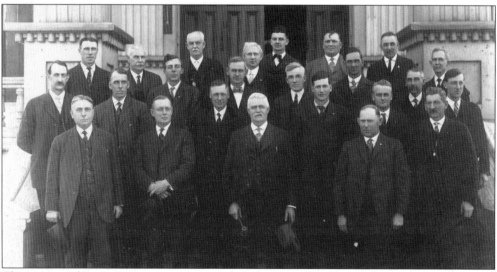

This picture of Lapeer's county supervisors dates back to 1915. From left to right are (first row) George Moore, Leon Schuneman, Alphonzo Baldwin (chairman), and Dan Cronin; (second row) William Swailes, H. D. Wilson, Archie Phillips, Ray Baker, Leo Laminan, and Thomas Newton; (third row) Albert Dan, J. E. Roberts, Byron Courter, Gus Schott, Eugene McGuegle, Norm Goodrich, James Stewart, and C. B. Schully; (fourth row) W. E. Myers (secretary of the poor board), H. W. Smith (prosecutor), George Carrigan (sheriff), Jerry Cardwell, George Dickerson (county clerk), and John Bohnsack (county treasurer). (Courtesy of the Byron Courter family and the LCHS.)

Decoration Day began after the Civil War in remembrance of the brave soldiers who died during the war. In this photograph, the crowd is congregating at the Urquart house, which is just across from the Stiles Cemetery. This house was thought to be a station of the Underground Railroad utilized for slaves to escape north to Canada before the Civil War. (Courtesy of Rachel Sitts Mackie and the LCHS.)

May 30 became the official day for Memorial Day, or Decoration Day, which originally honored only the men who had died in the Civil War. It now honors those who have died in all wars and is an established national holiday celebrated by parades and picnics. The Opperman house on this Memorial Day is getting ready to parade through the streets to the Stiles Cemetery. (Courtesy of the LCHS.)

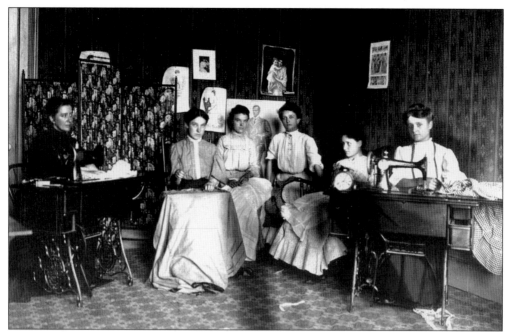

Sewing was one venue of opportunity for ladies to make a favorable means of income during the 19th century. Before electricity was invented, sewing machines had either a foot peddle or knee peddle that the operator would have to pump in order for the machine to operate. This picture shows both kinds of machines. (Courtesy of the LCHS.)

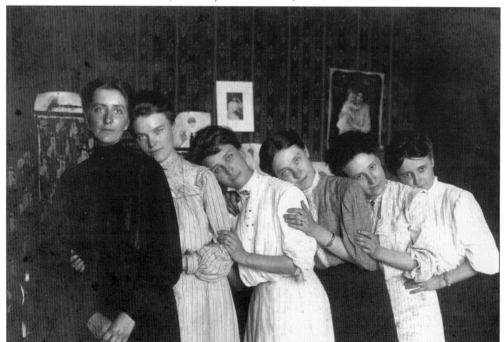

From left to right, an unidentified woman, Alma Dent, Allie (Pester) Loomes, Ada (Coulter) Rawleigh, Nellie (Sites) Reamer, and Bessie (Cumming) Crain-Koster take a moment away from their sewing machines and needles to pose for the photographer. (Courtesy of the LCHS.)

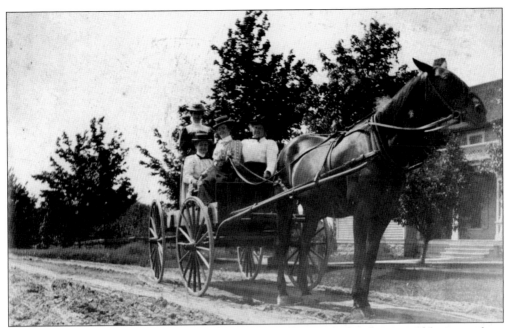

Summertime brought many young couples packing for the carnival and vacation-like atmosphere awarded them at Nepessing Lake. Pictured here are some young ladies about to depart for a weekend retreat in the early 1900s. (Courtesy of the LCHS.)

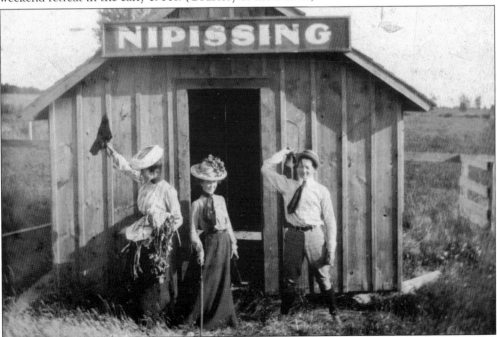

A vacationing group waits at this little depot at Lake Nepessing Road crossing. Notice the Nipissing sign. With the name taken from the Nepessing Indians who once inhabited the area, no one knew exactly which spelling was correct. The name would not be officially spelled "Nepessing" until sometime after 1896. In an interview with Peter Chatfield, he said the original spelling of the tribal name was "Nepissing." (Courtesy of the LCHS.)

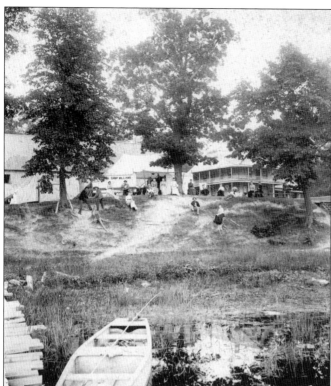

This 1902 picture of the Piper Resort Hotel and dance hall at Nepessing Lake depicts the gently sloping hillside of campgrounds, the spacious veranda of the hotel, and the rowboats awaiting a fisherman's pleasure. (Courtesy of the LCHS.)

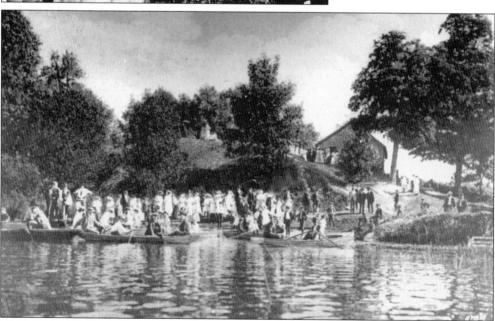

There were three different landings at Nepessing Lake. This is a picture of Lyle's Landing on the south side of the lake. It may be hard to believe, but in the early 1800s, Nepessing Lake was once the site of a large Native American encampment and was often called Indian Landing. In the mid-1800s, the Native Americans were taken to the reservation at Pleasant Lake, Isabelle County, and St. Clair River. (Courtesy of the LCHS.)

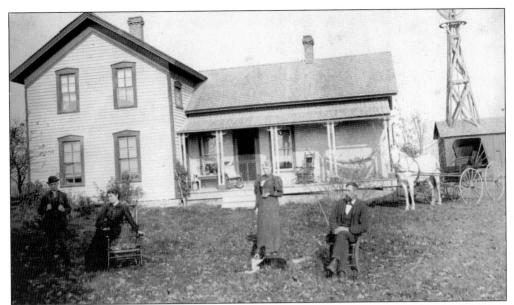

The Piper family takes a moment to rest at their home at 3714 West Genesee Road. Notice the large windmill in the background. In the early 1900s, very few farm homes were wired for electricity. Windmills were used as the main source of power, utilizing the energy of the wind. Windmills pumped water from wells for livestock and the families' cooking and household uses. Perhaps one of the couples is visiting, for the horse seems to be waiting for his owners to end their visit soon. (Courtesy of the LCHS.)

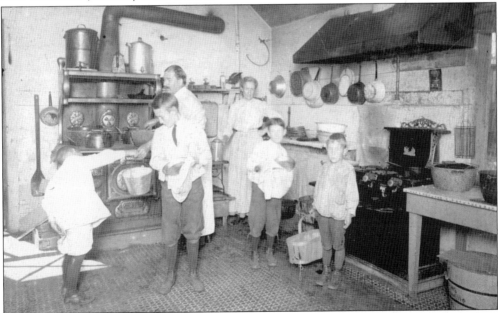

The Stiles Café in Lapeer was a popular eating spot located on Nepessing Street just down from the opera house in the late 1800s. Pictured here are four boys bustling about the kitchen tending to the many duties necessary in a restaurant establishment. The identities of the children are unknown, although they may be the children of the Stiles family or workers. During this period of American history, few child labor laws were in place. (Courtesy of the LCHS.)

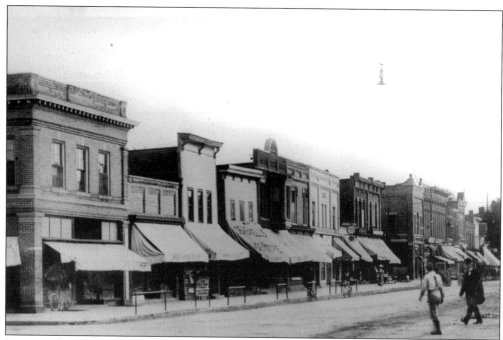

Lapeer's Main Street is ready for Saturday's shoppers. Hitching posts line the street, and awnings beckon cool shade for shopping pedestrians. In this 1910 photograph, a lady with hat and parasol strolls down the street and two men cross beneath the streetlamp dangling overhead. (Courtesy of the Best family collection.)

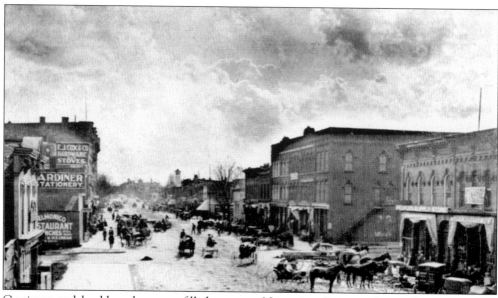

Carriages and buckboard wagons fill downtown Nepessing Street as far as the eye can see. Hitching posts lining the boulevard are filled to overflowing capacity, and the stately courthouse is seen in the far distance. Unable to find a parking place, some carriages are parked in the road in this picture from around 1900. (Courtesy of Don and Pat McCallum.)

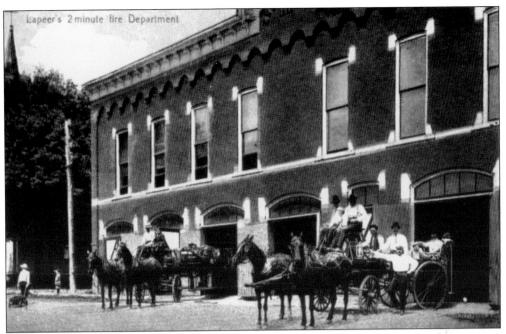

In 1882, the city council authorized plans for a new engine house for the Lapeer Fire Department. Hemingway, White, and Long built it for the sum of $6,000 and completed it in February 1883. It had a tall tower, a clock, and a cast bell weighing one ton. (Courtesy of the LCHS.)

Lapeer was incorporated as a village in 1857, and one of the signers was William H. Crocket. Crocket became the village's first marshal on March 2, 1858. In 1910, Michigan defeated the prohibition, but Lapeer County passed it and the town's nine saloons and one brewery became financially strapped. Whiskey stills, however, were a booming success, and the marshal often worked well into the night closing these home-brewed backhouse saloons. (Courtesy of Don and Pat McCallum.)

Lou C. Cramton, a circuit judge and state representative, spent his boyhood in Hadley. The Hadley Town Hall's most popular event was April's annual town meeting. It was the most important event of the year and instilled in the younger generation a respect for politics. Six boys adorned in straw hats lounge upon the town hall's prestigious steps. (Courtesy of V. G. Ivory and the LCHS.)

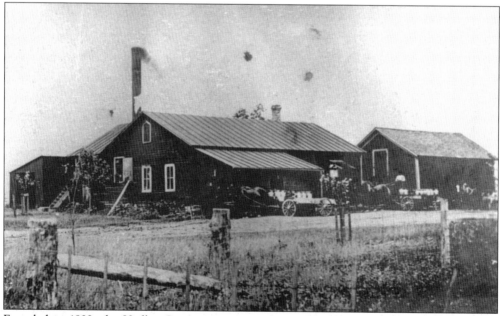

Founded in 1892, the Hadley Creamery continued to operate until 1963 and was the oldest operating creamery in Michigan. In 1939, the creamery output was 112,000 pounds of butter that year. At that time, Earl Wakeman was manager and Earl Ivory was president of the association. In Hadley, milking was done by the light of a lantern until 1934, and water for the livestock was pumped by a windmill. If the wind stopped, the farmer pumped it by hand. (Courtesy of the Hadley Township Historical Society.)

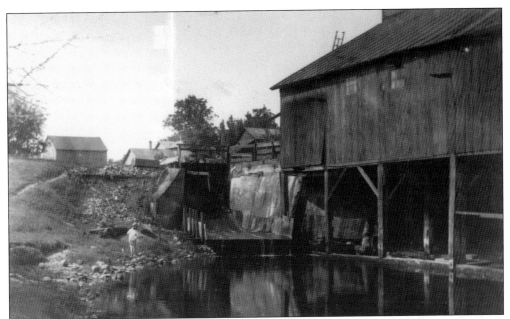

Built in 1845, the Hadley Mill burned down twice but each time was rebuilt. In the early 1900s, the mill's proprietor, Lee Miller, powered the mill by a waterwheel using water from the millpond out back. A steam-powered engine was used when the water table fell too low. In 1910, a gasoline-powered 20-horsepower engine was used. Here a boy checks out the depth and sees if the fish are biting. (Courtesy of the Hadley Township Historical Society.)

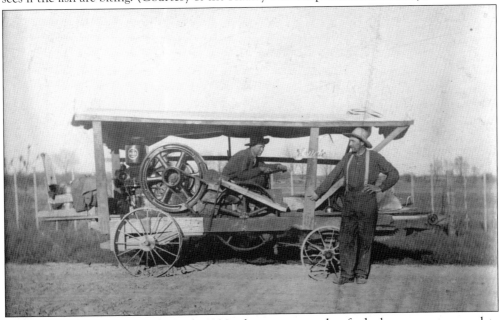

American ingenuity during the early 1900s always attempted to find a better way to complete the endless chores around the farm. In this photograph, two men wait with their portable sawmill for a team of horses to take them to their next job. This was a popular implement during barn raising, used to saw the rough lumber cut on site for the barn. (Courtesy of the Hadley Township Historical Society.)

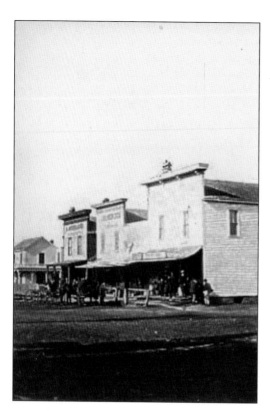

Mail was brought in once a day from Metamora by Archie Michael through Farmers Creek to Hadley. Frank Hadley, a descendant of the town's founder, operated the post office. For a while, the post office was in the general store, making it handy for farmers to pick up needed supplies and retrieve mail at the same time. (Courtesy of the Hadley Township Historical Society.)

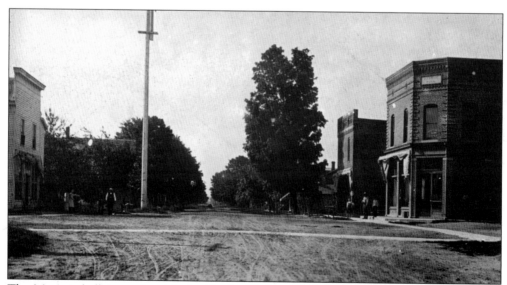

The Masonic hall is on the right beside the Hadley General Store started in 1901 by Earl J. Hemingway. The store carried a full line of groceries and clothing to fit the entire family, along with straw hats for $1 and men's suits for $12. (Courtesy of the Hadley Township Historical Society.)

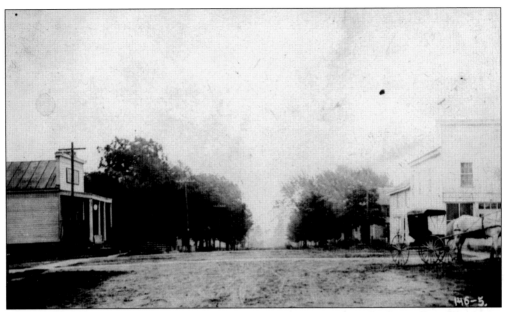

This is a picture looking east in Hadley. It was not uncommon to spot Dr. James Suiter's carriage on the road. Born in 1840 in West Virginia, he met Abraham Lincoln during a steamboat trip, which inspired him to enlist in the Illinois Infantry. He came to Hadley in 1866, and in 1877, he married Susan Davenport. His office was on the southwest corner of Hadley and Spring Streets. (Courtesy of the Hadley Township Historical Society.)

Taming the wilderness provides many surprises and, oftentimes, many disappointments. Hadley Township had two bad sinkholes located west of the village. One was reported as the biggest hole on any highway in eastern Michigan. The area stretched 350 feet, and 17,000 cubic yards of dirt were dumped and a floating trestle bridge over the remainder was placed, but it did little good as it would just sink out of sight. (Courtesy of the Hadley Township Historical Society.)

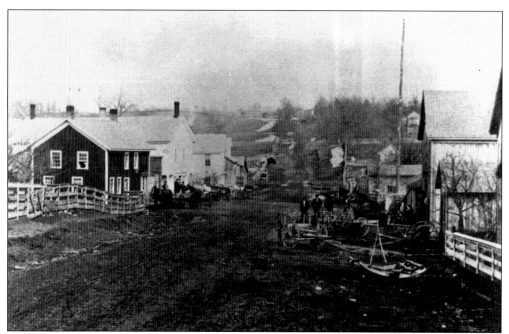

This 1873 picture from Metamora is of Dryden Road going east and is one of the earliest pictures known of Metamora. The rolling hillside stretched beyond the muddied streets and the framed houses. White picket fences were something of a novelty from the more common stump fencing normally seen. (Courtesy of the Best family collection.)

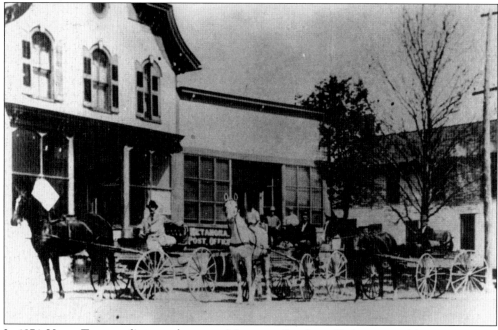

In 1874, Henry Townsend's general store on Metamora Road supplied patrons with an assortment of needs, from "findings," yard goods, and buttons to fresh ground coffee and penny candy. Townsend also made it convenient for patrons to pick up mail because the post office was attached to the store. (Courtesy of the Best family collection.)

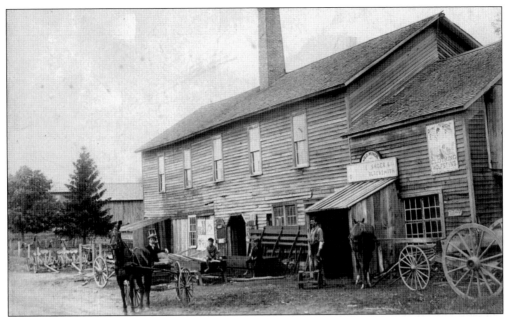

In the 1800s, blacksmiths would shoe horses and make horseshoes and other needed farms implements. Heating the steel or iron with woodstoves and coal stoves to a red-hot glow on their handmade forge, kept hot by hand-operated bellows, they would shape the shoe, yokes, or wheels with a hammer and anvil. In the far left corner of the photograph is a set of single plows waiting for their owners at this Lapeer blacksmith shop. (Courtesy of the LCHS.)

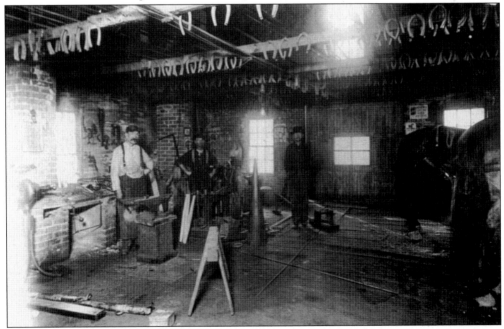

It is not known for sure whether this is the inside of Varnum's blacksmith shop or another blacksmith shop. Horseshoes line the rafters in this brick structure as the horses, ready to be shod, wait in their stalls for their new sets of shoes. The blacksmith's shop was a favorite gathering to catch up on the latest news. (Courtesy of the Davis family collection.)

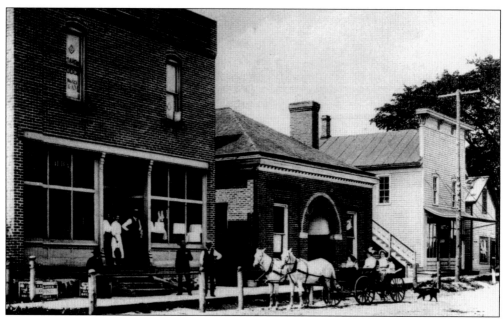

This picture shows the Barnes-Masonic Hall, built in 1907 by Marion Barnes as a combination store and Masonic hall. The town hall next to it was built in 1888. Caucuses, elections, talent nights, and traveling minstrel shows all found their way either to the steps of the Masonic hall or the town hall. The Masonic hall continues to serve the community, and the town hall building now houses the Metamora Historical Society. (Courtesy of the Best family collection.)

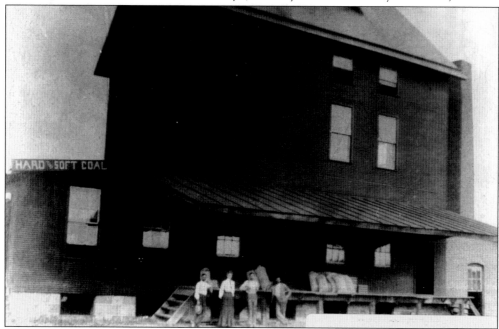

Metamora Elevator was built in the early 1870s, just about the time the railroad made its way to town. The elevator did grain milling and provided storage of fertilizer, wool, produce, lumber, and coal. From left to right, Harry J. French, Venus Van Kirk, Duane Lockwood, and Ben Cole stand in front of the massive building. (Courtesy of the Best family collection.)

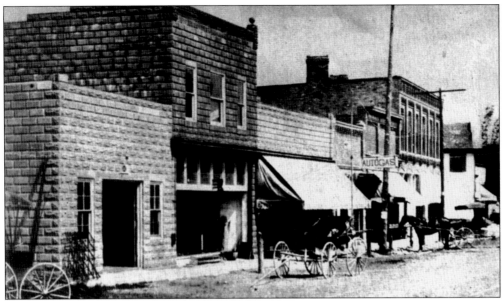

Three concrete structures were built in 1911 on High Street in Metamora: a one-story shop for the Lewis Brothers Blacksmith Shop, a two-story structure for the W. C. King Hardware Store, and a one-story store for the Barber-Walker Department Store. As the normal buckboard wagons pepper the landscape, the sign Auto Gas appears strangely out of place. Some Metamora residents owned automobiles, but for most, the choice of transportation was still the trusty horse and buggy. (Courtesy of the Best family collection.)

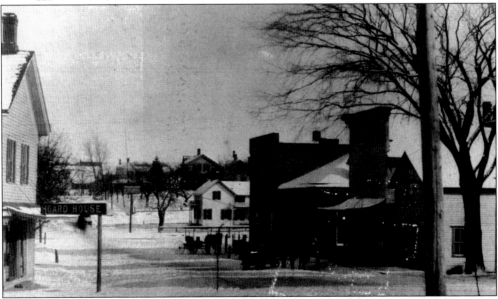

The Hoard House was built in 1850 and was first a stagecoach stop. When the Michigan Central Railroad was built in 1872, Lucy Hoard received a franchise to house and feed those passengers as she had fed the stagecoach passengers. Hoard did not mind feeding the Native Americans passing through Metamora (*Metamora* is a Native American name meaning "among the hills"). She even helped one Native American by giving him a knife so he could dress his deer. (Courtesy of the Best family collection.)

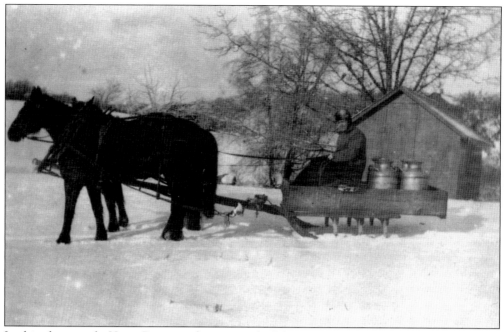

In this photograph, Harry Best is on his way to the Metamora Creamery with his milk. During the winter months, sleighs were hooked up to a team of horses, and the driver bundled up for the chilly ride. Usually a blanket would be wrapped around his legs for added warmth, as seen in this picture. (Courtesy of the Best family collection.)

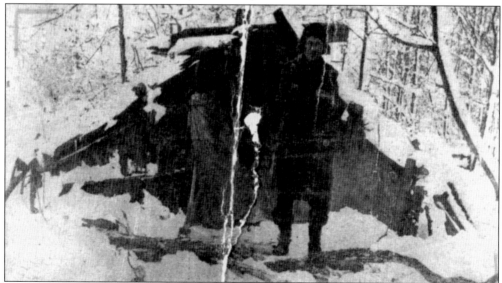

From the book *Indian Dave* by Dorothy Stott Dinsmore and Ann M. Hallock, after the "Black Smallpox" wiped out his family, Indian Dave became a familiar figure. Indian Dave often made cough syrup from the inner bark of the blue beech and ironwood trees for a sick child, his broken English explaining simply, "Me take boy, make med'cine, fix cough." In this 1910 picture, Indian Dave settles in to weather the winter months in his makeshift home. Indian Dave later sensed his impending death and asked "to ride in the pretty white wagon (hearse)" and "wanted the ladies of the church to sing like in white man's burial." (Courtesy of the Metamora Historical Society.)

Two

EVOLVING YEARS

By the spring of 1851, the courthouse battle seemed forgotten. By August, 10 or 12 new buildings had been erected with many more planned for fall and spring. Among those was the frame of the Presbyterian church. In the lower village, 19 offices, stores, and businesses were located. The upper village had its share of businesses, all needing a place to do their banking. Enoch J. White and Hubble Loomis founded a private bank in 1856, the predecessor of the First National Bank. Upon the death of Loomis, the bank was renamed E. J. White and Brothers. The three White brothers, Enoch J., Phineas, and Henry K., founded the First National Bank of Lapeer in 1871 and managed the bank for over 64 years.. The construction for the new First National Bank of Lapeer began on Nepessing Street in 1913. The major stockholders were B. F. Moore, G. W. Rood, Enoch J. White, Phineas White, and A. H. Piper. (Courtesy of the LCHS.)

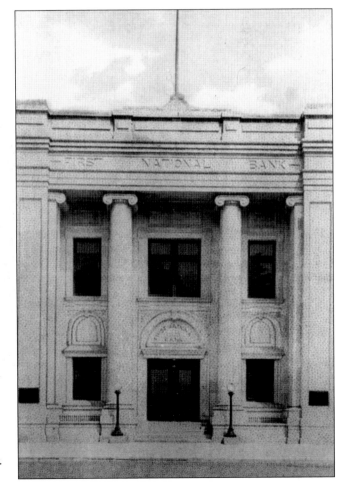

In this 1915 photograph, the seven gas streetlamps lining Nepessing Street were installed shortly after 1883 because of a petition from 87 Lapeer citizens. The first automobile came from Chicago, purchased by R. G. Hart in 1901. Nepessing Street was paved in 1904, and it unearthed many challenges for the excavators. Logs and crossways laid 50 years earlier when the region was just a swampland had to be dug up and removed. (Courtesy of the Best family collection.)

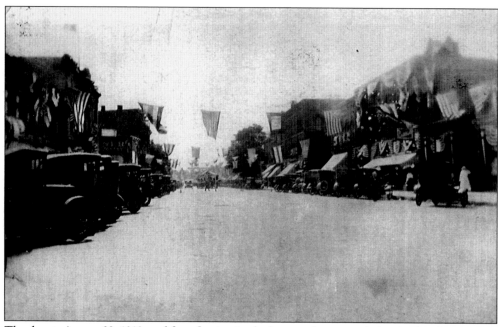

The date is August 22, 1919, and flags flowing in the breeze of a summer's day display the patriotic attitude of the merchants lining Main Street in downtown Lapeer getting ready for the Lapeer Days parade. Notice the many Motel Ts parked before the numerous storefronts. Business is booming. (Courtesy of the LCHS.)

In the late 1800s, banking laws did not allow a national bank to accept savings. Because of this, stockholders from the First National Bank began the State Savings Bank of Lapeer, beginning on June 1, 1891. Officers were Henry K. White, president; H. D. Rood, vice president; C. G. White, cashier; and J. R. Johnson, assistant cashier. When the banking laws were changed in 1929, the State Savings Bank was absorbed into the First National Bank. (Courtesy of the LCHS.)

The Caley family began the Lapeer Savings Bank in 1902 with $25,000. In 1910, the savings directors bought the Watkins property on Nepessing Street at Pine Street, and by the spring of 1913, the bank was in its new building with resources totaling $332,313. The bank owned the main floor, and the second story was built and owned by Lapeer Masonic Temple. The temple was later purchased by the bank. (Courtesy of Don and Pat McCallum.)

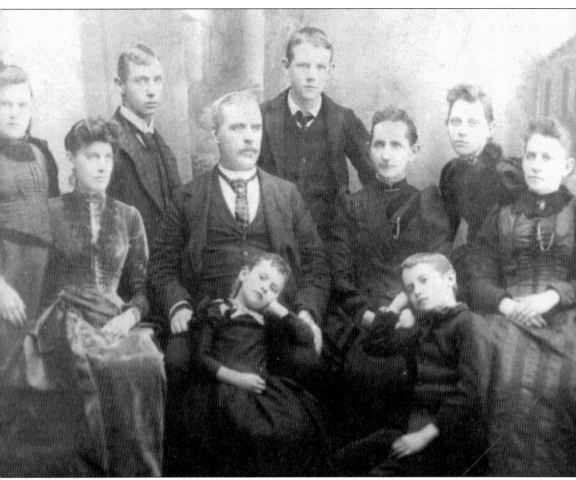

Back in 17th-century England, the family name was spelled "Bostwick." The spelling change was made by Alonzo A. Bostick. Alonzo A. Bostick was raised in Hadley, and when he was a young man, he went to Millington and started a blacksmith shop and later a factory. He made agricultural implements and began working with casting metals and made stoves and sleighs for almost 20 years. In 1901, he decided to move to Lapeer, where he concentrated on making castings. Alonzo married twice. This is a picture of Alonzo and his first wife, Lucy (Thompson) Bostick (who died on April 14, 1893), posing with their children. From left to right are (first row) Mary Blanch (born on February 22, 1884) and Arthur Lee (born on May 18, 1880); (second row) Ella Blanch (born on March 26, 1878); Sara Jane, also known as Jennie, (born on April 19, 1867); Alonzo; Lucy; Minnie Belle (born on June 30, 1872); and Caroline Ella, also known as Carrie, (born August 27, 1864); (third row) Austin Danverse (born on December 22, 1870) and Andrew Madison (born on April 16, 1876). Alonzo and his second wife, Florence (Fireman) Bostick, had three more children named Coral, Harold, and Eloise. Florence died on April 27, 1923, and Alonzo died on January 12, 1920. (Courtesy of the LCHS.)

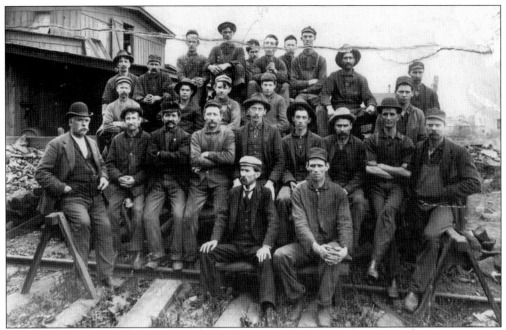

Bostick owned a business in Millington with his son Austin D. Bostick that was first called Alonzo A. Bostick and Son. When he moved to Lapeer in 1901, he renamed the family business to Bostick Stove Works. Its grand opening celebration began the idea of Lapeer Days on August 28, 1901. Bostick Stove Works became Bostick Foundry in 1932. Seen here are the Bostick employees with Andrew M. Bostick sitting in the top row, second from the left. (Courtesy of the LCHS.)

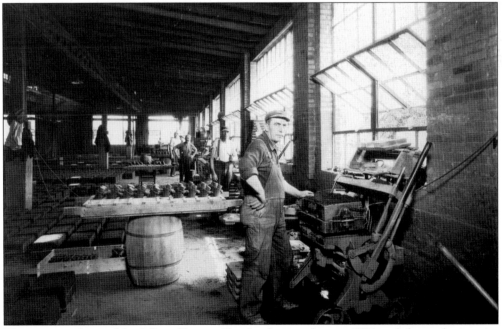

This picture, donated by Lillian Harvey Shepherd, was taken in 1926 and shows the interior of Bostick Foundry. The man in front is Joe Conant, and the man in white is Lester Harvey. (Courtesy of the LCHS.)

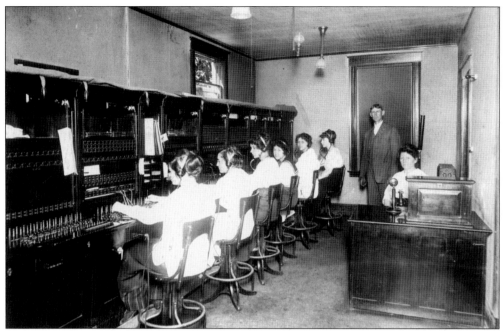

These female switchboard operators were capably equipped to handle any situation and willing to work well below wages paid to men. However, working conditions for women and children were changing. In 1910, female employees, due to state labor regulations and inspections, changed to a 9-hour workday or an average of no more than 54 hours a week. (Courtesy of the LCHS.)

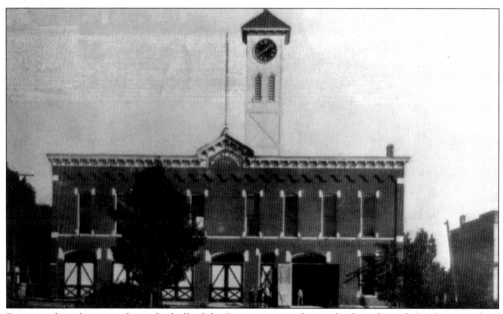

Because the vibrations from the bell of the Lapeer engine house had weakened the framework of the tower and the clock had stopped running, the city gave the contract to Archie Van Wagnen to remove it. On May 23, 1941, Van Wagnen began easing the bell down, but it dropped and a timber hit a man on the head, breaking his neck instantly. (Courtesy of the LCHS.)

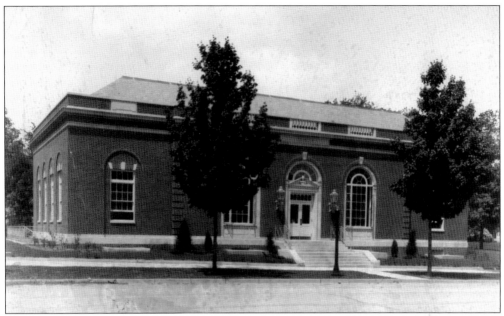

The Great Depression was felt by everyone in the 1930s, and tax sales peppered the countryside with the telltale signs of widespread poverty. The Lapeer Post Office Project was begun to encourage the struggling economy of Lapeer. The post office was operable on June 10, 1933, and stands at the corner of Nepessing and Calhoun Streets. The cost to construct the City of Lapeer Post Office was $55,000. (Courtesy of Don and Pat McCallum.)

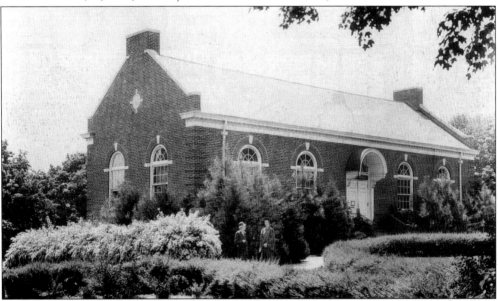

The Lapeer Ladies Library Association was founded in 1859 and encouraged the Carnegie Foundation to award $10,000 to build the Lapeer Public Library in 1916. However, it was through the efforts of Congressman Louis Cramton that a larger grant was obtained. In 1981, the library was renamed the Marguerite de Angeli Library. Born in Lapeer in 1889, Marguerite de Angeli became a famous writer, winning the Newbery Medal as a children's author and illustrator. (Courtesy of the LCHS.)

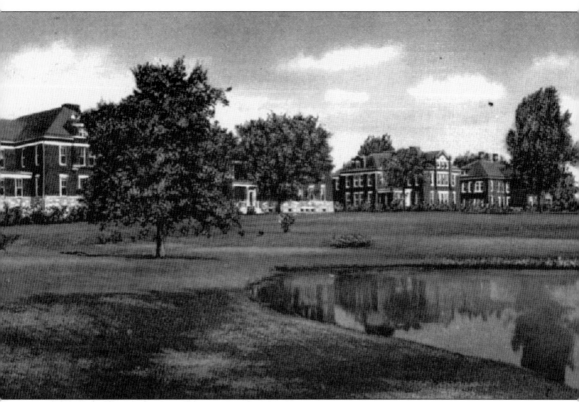

The 160-acre facility of the Lapeer State Home and Training School opened its doors in June 1895 for the feebleminded and epileptics. By 1919, the patient quota climbed to 1,560 with 500 patients being of school age and considered to be trainable, so four teachers and five attendants were hired. Eleven new cottages were built. By 1959, there were 602 employees, which escalated to 1,386 employees and 4,400 patients. The Lapeer State Home and Training School became known as one of the largest facilities of its kind in the nation. In 1976, the patient load drastically reduced because the state began to build smaller units closer to the homes of the patients, which resulted in the Lapeer State Home and Training School being demolished in 1996. Only the cupolas were salvaged and placed sporadically in downtown Lapeer. (Courtesy of the Best family collection.)

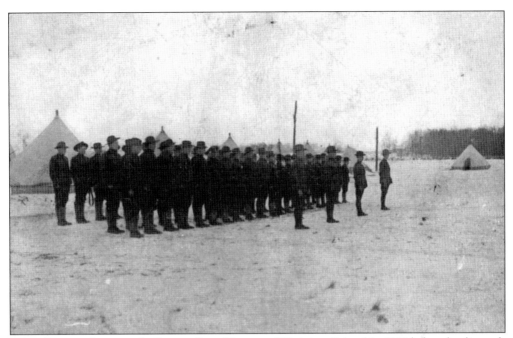

A smallpox epidemic in the Lapeer State Home and Training School in 1910 led to the dispatch of the Flint National Guard. They camped in tents on the grounds during the fall and winter months. The outbreak was contained to the asylum grounds, and many victims of smallpox were buried in a cemetery at the south edge of the grounds. (Courtesy of A. Gillett and the LCHS.)

During the 1800s, sailing was important for commerce in the Great Lakes states. One Great Lakes sailor was Capt. George Rogers, who built his home on Adams Street, retired, and died there. (Courtesy of the LCHS.)

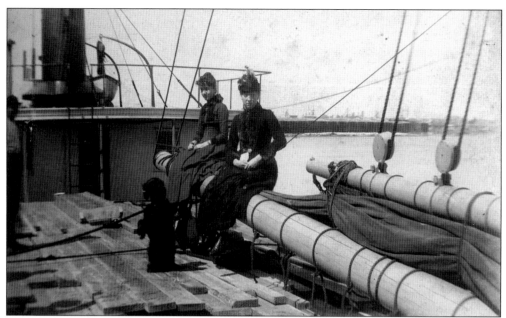

Capt. George Rogers's boat was steam powered and sailed the Great Lakes throughout the spring, summer, and fall months. This picture from April 7, 1888, shows Rogers's sister, Nellie Rogers, with Mrs. Frank Cutting and John, Cutting's dog. (Courtesy E. E. Des Jardins, Mrs. Byron Duckwall, and the LCHS.)

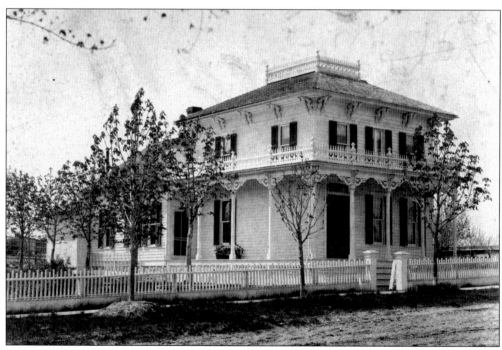

Capt. George Rogers and his wife, Rachel, lived at 617 Adams Street. Rogers was also the great-grandfather of Georgie (Des Jardins) Duckwall. Rachel Rogers was Rachel Louis (Thumb) Rogers. (Courtesy of the LCHS.)

Built by Peter Van Dyke in 1875 and located on Pine Street, this private residence is a beautiful example of French Second Empire architecture. Van Dyke later sold the house to Samuel Tomlinson, editor of the local newspaper the *Lapeer Clarion*. Tomlinson's son, George, became one of the great steamship and railroad moguls of the nation. John Williams was the next owner, followed by Robert White, who owned Lapeer Brick and Tile. (Courtesy of Don and Pat McCallum.)

The Hunter sisters bought this home in 1924 and renovated it to a 9-bed hospital, increasing it to 18 beds during their 29 years of occupancy. Frances was a registered nurse and Mary Ellen acted as administrator. The Hunter sisters lived on the first floor where the patients' food was prepared, the second floor was used for surgery, and the third floor was where patients stayed. The hospital operated until 1953. (Courtesy of the LCHS.)

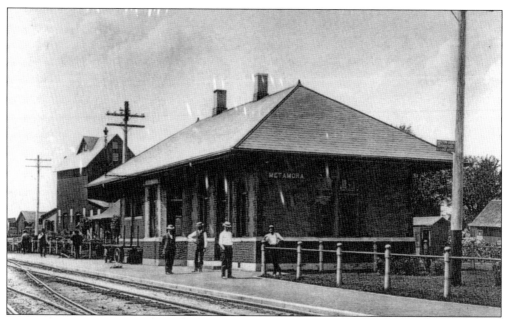

With the railroad, farmers could market their produce faster and easier. This brick railroad depot was called Metamora depot, built in 1907. Across the tracks of the Michigan Central Railroad, the stockyards were kept for shipping cattle, hogs, and sheep. Telephone poles line the perimeter, and a Western Union Telegraph and Cable Office is advertised on one of them. (Courtesy of the Best family collection.)

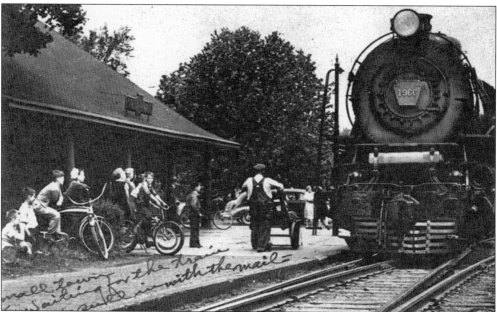

Railroads encouraged growth and economic gain, both to the community and to the individual. Young boys got a thrill seeing the iron horse lumbering to a steaming halt, bringing in news from afar and taking their letters to the unknown distant lands. The highlight of a boy's day back in the early 1940s was to be there when the passengers disembarked and the mail was loaded. (Courtesy of the Best family collection.)

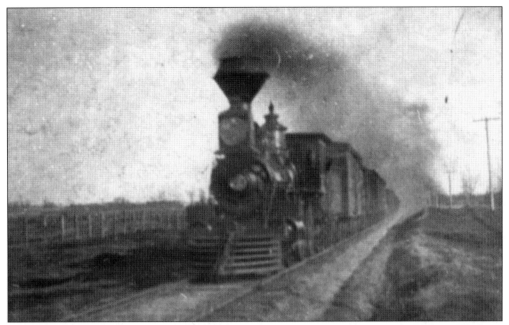

Trains lumbering down the tracks through the sparse country miles during the dry months of summer and fall brought with them an alarming problem. Fires sometimes erupted along the parched grass or unpainted surfaces of old and withered buildings from the glowing ashes spewed out of the train's smokestacks. (Courtesy of T. H. Scott and the LCHS.)

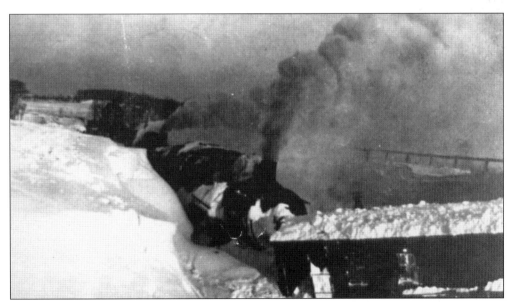

During the winter months, the trains had to contend with snowdrifts across the train tracks. Even though this train is equipped with a snowplow in the front, it is still having a rough time navigating its way down the tracks. (Courtesy of T. H. Scott and the LCHS.)

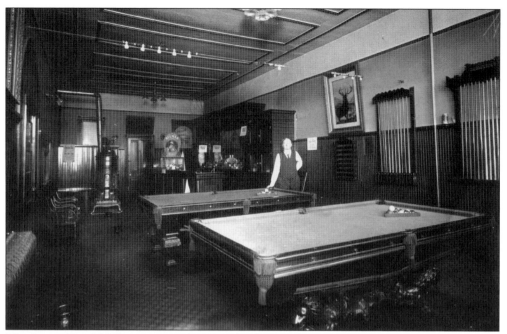

The Lapeer Pool Hall was a popular spot for the gentlemen of Lapeer to congregate for an evening of leisure with cigars and sport. A woodstove sits in the center back, and tables and chairs line the wall. In the far corner is a bar with a keg labeled "Sweet Cider" sitting on the counter. (Courtesy of the LCHS.)

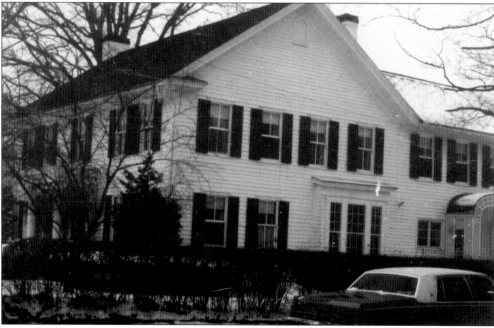

The Lapeer Eagle Tavern was first a stagecoach stop and then a tavern that weathered the Prohibition years. During the food-control legislation in the days of World War I when the manufacture of whiskey and beer was banned, the Lapeer Eagle Tavern became the home of E. J. White. (Courtesy of the LCHS.)

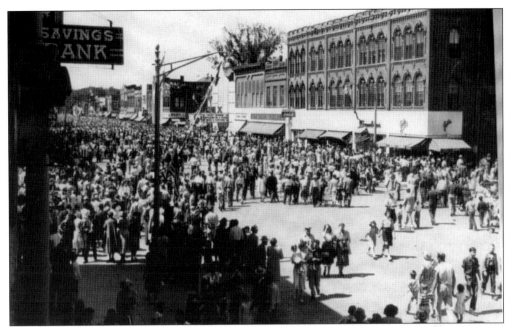

The prestigious Lapeer Savings and Loan Bank shadows Main Street and the pedestrians beneath. The streets are filled to overflowing capacity with Lapeer residents and out-of-towners enjoying downtown in the early 1950s. The PIX Theater, built in 1941, provides live theater entertainment, musical productions, and many community programs. (Courtesy of the LCHS.)

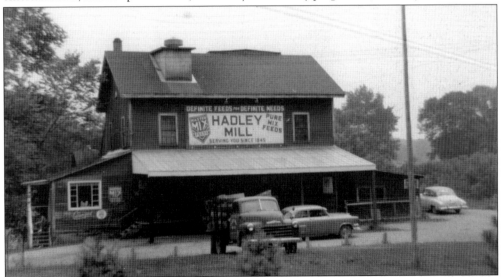

The Hadley Mill continued to flourish during the 1940s and 1950s, supplying the population with "Definite Feeds for Definite Needs." An auxiliary-powered engine was used during that time. Not until the 1960s did Hadley Mill cease operations. Mike Hartwig, the youngest son of Ralph and Marie Hartwig, recalls when he used to shovel corn at the Hadley Mill to make grain for the cows. Ralph and Marie bought the mill as their second home, preserving many historical artifacts. Upon Ralph's death in 2003, Marie donated the mill to Hadley Township, and the mill became the Hadley Township Historical Society. Many farming demonstrations and exhibits are displayed here throughout the year. (Courtesy of the Hadley Township Historical Society.)

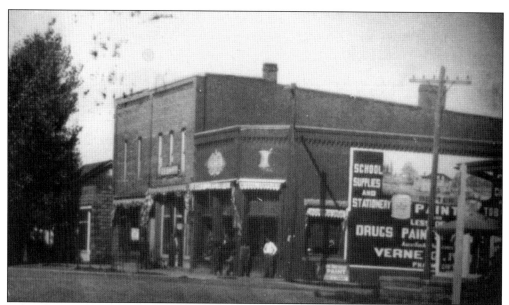

In 1903, George S. Hutton started the Hutton Drug Store and sold the building to Egbert Ivory and his son Verne G. Ivory, who named it the Ivory Drug Store. Verne began making postcards depicting Hadley buildings and sold them around 1907. In this image, the east wall is painted with advertisements. (Courtesy of Mrs. Harry Monroe and the LCHS.)

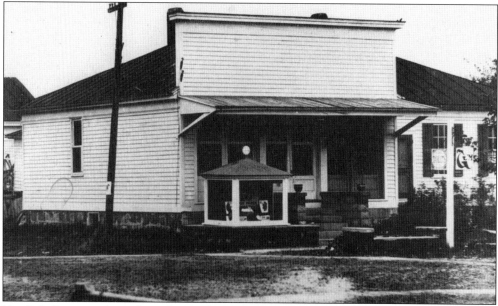

Nowlin's Store was located on the northeast side of the four corners of Hadley. Frank Nowlin repaired clocks and watches of all kinds. The store had living quarters attached to its east side, and to the rear was a storage barn with a catwalk from the store to the second story of the barn. The store was later sold to Warren Green. (Courtesy of the Hadley Township Historical Society.)

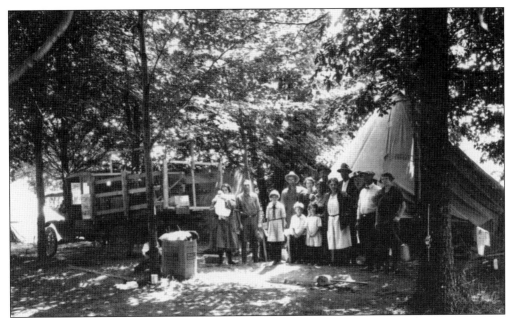

A Model T truck loaded down, a makeshift tent spread between two trees, and a mother clutching her infant with her children surrounding her was an all too familiar sight during the late 1920s and early 1930s. During the Great Depression, many families were uprooted from their homes and forced to seek employment in other counties and states. However, in this picture, the Ivorys were only out for a camping trip that occurred in 1925, just a few unsuspecting years before that migration. (Courtesy of Betty Ann Ivory.)

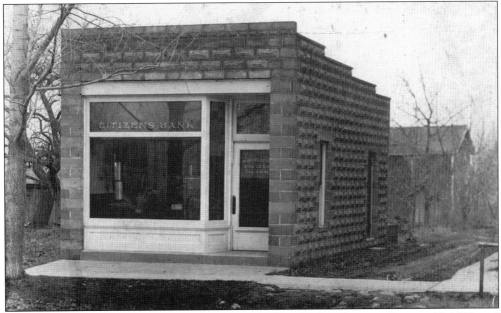

The Citizens Bank of Hadley, located on Pratt Road, opened its doors on January 10, 1910, and made Hadley history on October 28, 1937, when two bandits robbed it of $560. The interior of the bank was kept in the Ivory barn till Norm and Anneke Bullock renovated it and placed it in the Bullocks' ancestral estate. (Courtesy of the Hadley Township Historical Society.)

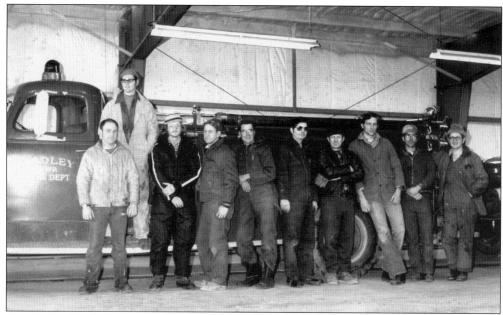

The Hadley Fire Department was created in 1937, in 1952 it was able to purchase this fire truck, and in 1975 it got its new fire hall. Hadley's volunteer fire group is seen here: Dick Schank is on the step, and the others are, from left to right, Chief Jack Lunison, George Gleaso, Jerry Painter, Clinton Ivory, Carl Langey, Ed Green, Dick Nass, David Ivory, and Ed Rose. (Courtesy of Clinton Ivory.)

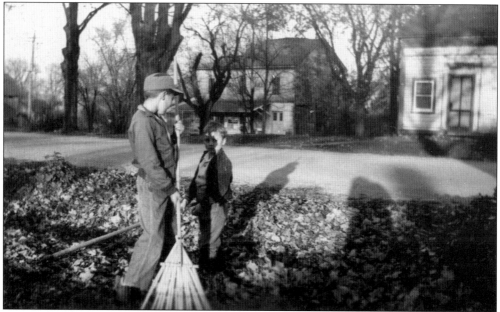

The evening shadows grow long against the setting sun off Hadley Road, creating what appears to these two boys as an endless chore of raking leaves. Young 10-year-old Kent Copeman looks around to see younger brother Jim totally disinterested in the task. Kent became a teacher for the Lapeer School District and an artist. His water paintings depict many historical landmarks of Hadley. (Courtesy of the Hadley Township Historical Society.)

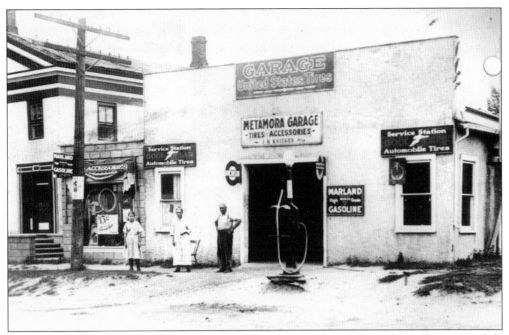

The Metamora Garage provided gas, United States tires, and many accessories that automobile drivers would find hard to purchase in 1918. Mr. and Mrs. Jerry Kreiger and their daughter Ruth watch on with hopeful anticipation for the next driver not in a horse-drawn buggy to appear. (Courtesy of the Best family collection.)

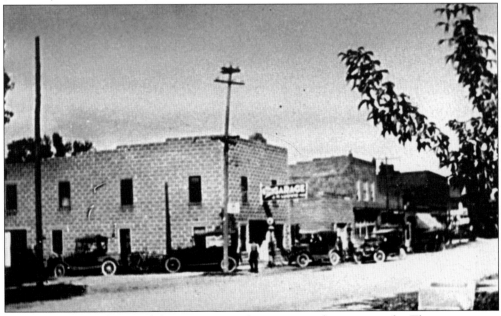

Service stations and automobile garages seemed to spring up almost overnight. There were seven gas stations in the village of Metamora at one time. Here the Model Ts wait in line in 1925 at Julius Ludwig's. Lewis Brothers Blacksmith Shop has been replaced. A picture of Earth with a Goodyear tire encircling it, with the words "Goodyear Means Good Wear," is seen on the sign over the door. (Courtesy of the Best family collection.)

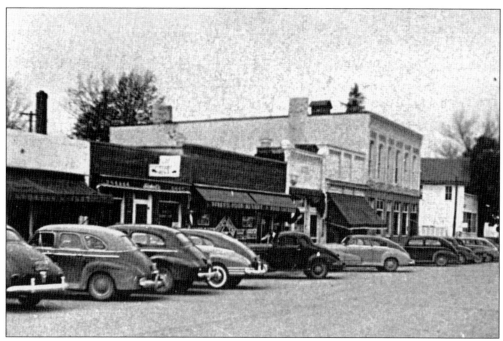

During 1939 and 1940, the Metamora Business District sported many new businesses: Bobby's Food Market, a bakery, millinery, and fish market, with Metamora Bank at the corner. Presently these buildings house the Metamora Library and Design Works, which provides creative exhibits and handcrafted jewelry. (Courtesy of the Best family collection.)

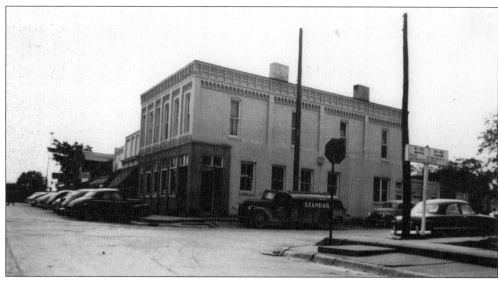

The Metamora Bank, established in 1879, was complete with an up-to-date and modern walk-in bank vault with solid lead walls. Now the building is A Bit Used Tack Shop where equestrians can buy used saddles and clothing, and the bank vault is used as a dressing room. Those walls were there to stay. (Courtesy of the Best family collection.)

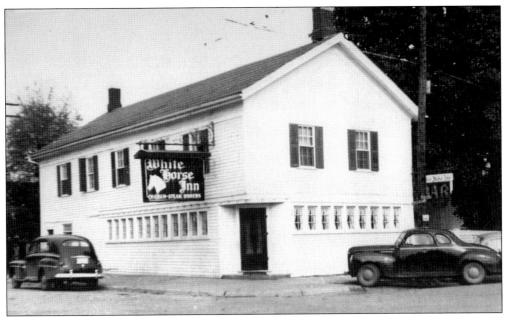

The Hoard family sold the Hoard House to Gilbert Olds. Olds liked to go around town without shoes. Frank Peters then bought it, changing the name to White Horse Inn during Prohibition, and made the inn successful in promoting breakfast specials. The highlight of the day was going to the train depot and picking up one's mail. Then everyone would go to the White Horse Inn for breakfast. (Courtesy of the Best family collection.)

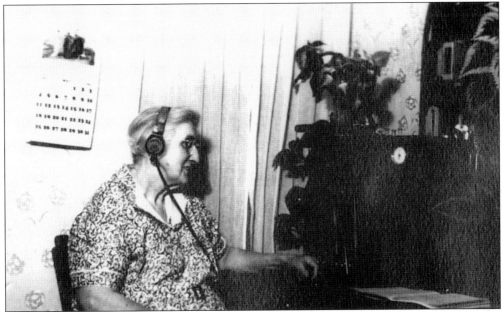

"Hello, give me Roy's" was a phrase commonly heard by Alice Reed, who would punch in the line on her switchboard. The old crank telephones are all gone, and ringing the operator is a thing of the past. But during the 1940s, Reed would gaze out her window and wait for that voice to come in over her receiver and ask for a connection. She knew everyone and had her switchboard pegs memorized. (Courtesy of the Best family collection.)

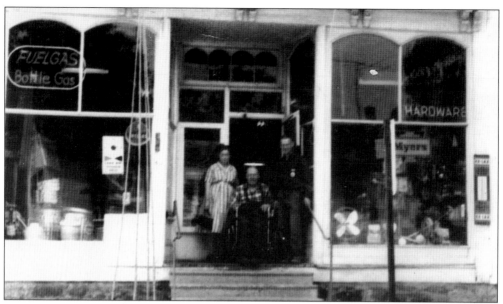

Mr. and Mrs. Walker, along with their son, Floyd, bought the Townsend Store sometime in the 1930s. This picture was taken in 1947 and shows the family upon the steps of their hardware store. Notice the bamboo canes in the front. They were popular fishing poles back in the 1940s, and the ring that held them secure in the scrolled roofline was not discovered until many years after Floyd retired from his store. (Courtesy of the Best family collection.)

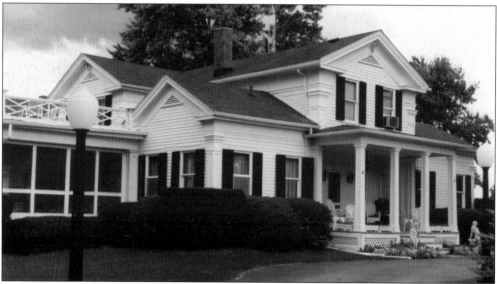

The Clark family owned two and a quarter square miles in Hunters Creek; they owned and operated their own lumber mill, tanning mill, and hotel and generously donated land for the Hunters Creek Baptist Church. In 1857, they tore down their first house, an 1,800-square-foot log home, so they could build this 4,200-square-foot classic Colonial. They camped out in tents until the house was complete. Through the Great Depression, the family faced a couple of sheriff sales, but the Clarks' optimism managed to get them back on their feet. The Clarks presently live in Oklahoma, and Weston Wickham is the proud owner of this beautiful estate. (Courtesy of Weston Wickham.)

Three

CHURCHES

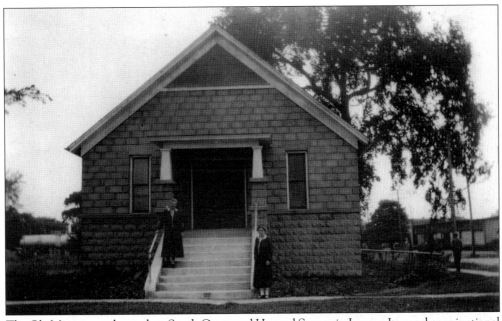

The Ole Mission was located on South Court and Howard Streets in Lapeer. Its nondenominational services were held Friday night and Sunday afternoon, so not to interfere with other church services. The building was special to the children of the community. Abbie Fox, or "Aunt Abbie" as everyone knew her, bought the house with the aid of Lapeer citizens. Around 1920, the mission was replaced by a cement block building. In 1941, the building was sold to the Nazarene church, with the proceeds turned over to the station WMPC (Methodist Protestant Church) as stipulated in the mission's bylaws. Aunt Abbie wrote a seven-stanza poem about the Ole Mission. This stanza was a fitting eulogy to the fine services the Ole Mission rendered to everybody seeking a place to worship: "Prepare us, Lord, to watch and pray, / To work to save some souls from sin / To seek the lost sheep who are astray / And bring them to Christ's fold again. / When He, whose right to reign shall come / With crowns and scepter given, / Our days well spent, our work well done / Our name enrolled in Heaven." (Courtesy of Don and Pat McCallum.)

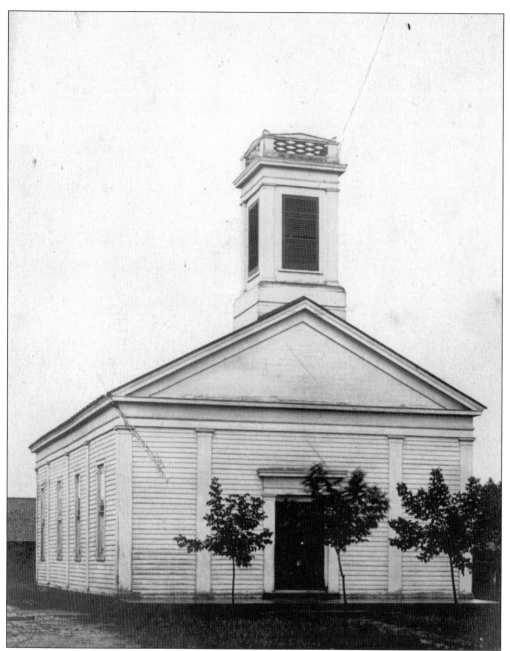

In 1836, Hadley contained no more than nine families. Traveling was done by the aid of marked trees because there were no roads cut out at that time. Rev. James Hemingway preached the first sermon in a log shanty, and it was said that every person living in town was present. In 1837, Rev. W. D. Potter became the first pastor. Oran Mitchell followed and, during his administration, Hadley had a sweeping revival commencing at a "temperance meeting." With two exceptions, all the adult population was converted in the township to Christianity, and the township received the title "Pious Hadley." The Baptist Church of Hadley officially began in 1838 when a council of delegates held a meeting in the barn of William Hart. (Courtesy of the Hadley Township Historical Society.)

A lot deeded to the Methodist society by Alonzo and Amanda Hart on February 15, 1842, founded the Methodist Episcopal church in Hadley. The church was erected at a cost of $4,500 and completed on May 12, 1870. The first board of trustees comprised James Hemingway, William Hart, Simon T. Hill, Jonathan Cramton, and William Hemingway. The church sanctuary, balcony, and portrait of Jesus Christ preside in their original state. Some grave markers of the cemetery behind the church date back to 1799. (Courtesy of the Hadley Township Historical Society.)

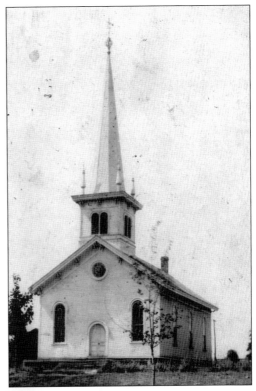

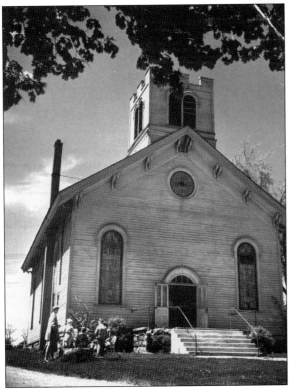

The steeple of the Methodist Episcopal church in Hadley was blown down in March 1913 during a terrible windstorm. In 1919, the Baptist Church of Hadley federated with the Methodist Episcopal church. The pews were brought over from the Baptist church, and the Baptist church building was used as the community hall. In 1949, due to the spiritual growth of both churches, the Baptist Church of Hadley reorganized and added onto its old church. The Methodist Episcopal church became Hadley Community Church in 1966. Hadley Community Church's new church steeple bells, the Carolina, chime every hour from noon to 6 p.m. (Courtesy of the Hadley Township Historical Society.)

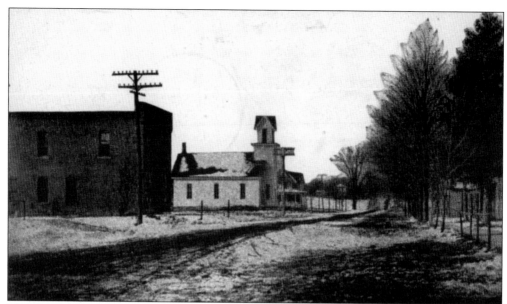

The Free Methodist Church of Hadley was organized in 1876 with John Wetherold as pastor. Located east of the village, the land was purchased from John and Sarah A. Davenport for $100 on December 13, 1892. In 1922, the church edifice was sold to the Free Methodist Society and moved by horse and wagon to Mechanic Street in Oxford. (Courtesy of the Hadley Township Historical Society.)

The burnished-white steeples of the Metamora Congregational Church and the Metamora Methodist Church etch a gleaming backdrop to this December scene, which dates back to the late 1800s. The early settlers of Metamora brought their zeal for Christianity into every aspect of life, even into the purpose of education, striving as *Metamora Among the Hills* says, "to train a child to read and interpret the word of God." (Courtesy of the Best family collection.)

The Pilgrim Congregational Church was established in 1878 and located on High Street. In the early 1900s, the Pilgrim Congregational Church became the Pilgrim Presbyterian Church and the center of social life for the family. During their "poverty social," everyone was expected to wear old clothes and eat johnnycakes, mush, and milk like their ancestors did years ago. The 60-foot belfry tower and 1,750 square feet of vaulted ceiling stand today, unaltered. (Courtesy of the Best family collection.)

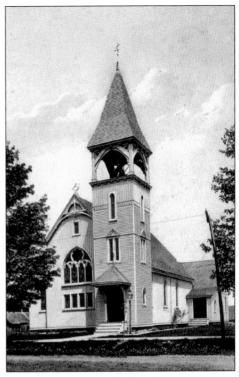

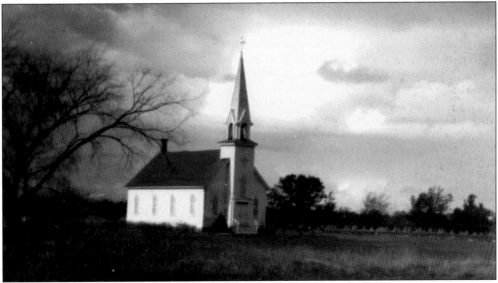

On May 28, 1879, the one-room Hunters Creek Baptist Church was ready for service. The building cost $1,500, including the bell in the steeple. Known now as the Hunters Creek Community Church, Pastor Maurice Horn became the preacher in 1945 and was known as the "walking preacher" because his chief means of transportation was walking except for the times he borrowed his neighbor Lilley's horse. Hunters Creek contributes its continued ministry to those pioneers who began the church and states in its preface, "By God's grace we are building on the foundation laid, as we remain committed to exalting Christ through evangelism and discipleship in our community and around the world." (Courtesy of the Hunters Creek Community Church.)

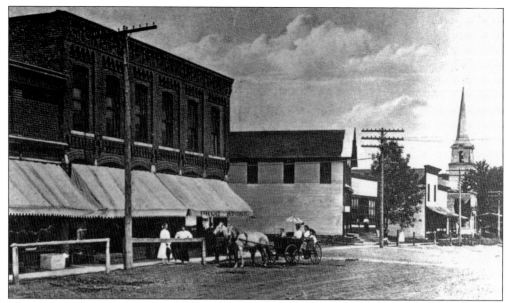

This early-20th-century picture of Metamora's Oak Street looks north. It affords a clear view of the Methodist church that was built in 1874. In November 1919, the church was sold. It was torn down and placed in Goodrich. Notice the ladies out for a buggy ride, parasol in hand, adorned in big-sleeved blouses and tight-wasted gathered skirts. American illustrator Charles Dana Gibson first drew the famous Gibson girl, which became a favorite style of dress in the United States around 1900. (Courtesy the Best family collection.)

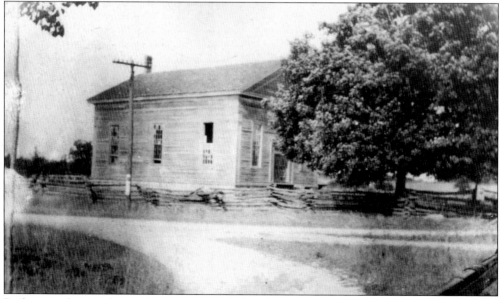

Built around 1846, the Methodist Episcopal church was a part of the Lapeer circuit. Ministers rode in on horseback preaching the word of God to the various churches that could not afford a full-time preacher. Located on the northeast corner of Clark and Hunters Creek Roads, it remained active until 1866 when the church lost ownership. The building was torn down or moved sometime after 1900. This photograph was provided by Mrs. James Cathers, whose husband was buried in the Farmers Creek Cemetery in 1846. (Courtesy of the LCHS.)

Four

CULTURE

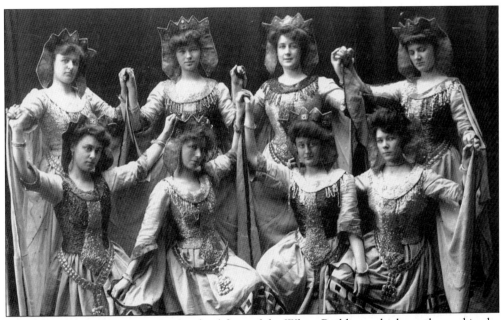

In 1871, the opera house was on the third floor of the White Building, which was located in the upper village of Whitesville. Enoch J. White erected this building as the intended courthouse and main business section. When the railroad was placed in the lower village of Lapeer, it became apparent where the main business section would be. The opera house was known as one of the finest in the state, and Abbie Cutting, Lena Armstrong, Lucille Kelley, Maud McNamary, Auria Vosburgh, May Fuller Thompson, Icieleen Churchill, and Mauri Pike pose after a play upon its lavish stage. In 1879, one year after White's death during the Prohibition movement, Susan B. Anthony became the last celebrity to appear on stage at this location. The White Building was dismantled and moved piece by piece to the corner of Nepessing and Court Streets. Its social activities continued into the mid-1920s. It became a ballroom in the 1930s and, later, the third story was sealed off. The first and second floors are used as offices, restaurants, and retail stores. (Courtesy of the LCHS.)

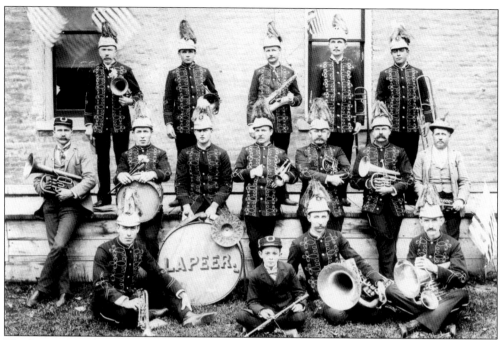

The Lapeer Marching Band was well known and created a colorful figure with its uniforms and brass instruments. The townspeople enjoyed listening to it. (Courtesy of the LCHS.)

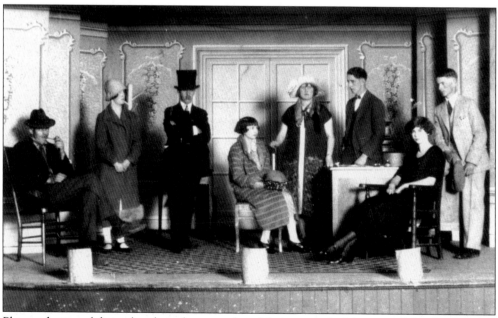

Plays and minstrel shows, bands, and quartets found their way to the Metamora School auditorium throughout the years. The Metamora Merchants contributed their share to entertaining the Metamora community by utilizing the Hoard House's vacant lot and stringing sheets between trees to create the first outdoor movie screen and playing old cowboy films to the community's delight. (Courtesy of the Best family collection.)

Started in 1928 and continuing through the Depression years, the Lapeer Wigwam Players presented plays, puppet shows, and musicals at the Lapeer High School auditorium. One year, they took their theater presentation *Side Show* to New York City. (Courtesy of Dorothy Davis and the LCHS.)

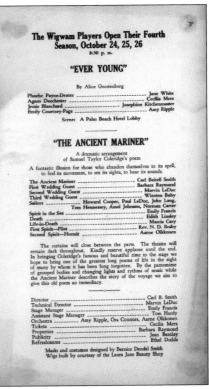

The Wigwam Players Open Their Fourth
Season, October 24, 25, 26
8:30 p. m.

"EVER YOUNG"

By Alice Gerstenberg

Phoebe Payne-Dexter ------------------------------ Jane White
Agnes Dorchester --------------------------------- Cecilia Merz
Jessie Blanchard ------------------------ Josephine Kitchenmaster
Emily Courtney-Page ----------------------------- Amy Ripple

Scene: A Palm Beach Hotel Lobby

"THE ANCIENT MARINER"

A dramatic arrangement
of Samuel Taylor Coleridge's poem

A fantastic illusion for those who abandon themselves to its spell,
to feel its movement, to see its sights, to hear its sounds.

The Ancient Mariner --------------------- Carl Beitell Smith
First Wedding Guest ---------------------- Barbara Raymond
Second Wedding Guest ---------------------- Marvin LeDuc
Third Wedding Guest ------------------------ Winston Buby
Sailors ------------- Howard Cooper, Paul LeDuc, John Lang,
Tom Hennessey, Amol Johnson, Norman Carter
Spirit in the Sea ------------------------- Emily Francis
Death ------------------------------------- Edith Linsley
Life-in-Death ------------------------------ Marcia Cary
First Spirit—Pilot --------------------- Rev. N. D. Braby
Second Spirit—Hermit ---------------------- Aarne Olkkonen

The curtains will close between the parts. The theatre will remain dark throughout. Kindly reserve applause until the end. In bringing Coleridge's famous and beautiful poem to the stage we hope to bring one of the greatest long poems of life in the sight of many by whom it has been long forgotten. By the pantomime of grouped bodies and changing lights and rythms of music while the Ancient Mariner describes the story of the voyage we aim to give this old poem an immediacy.

Director ----------------------------------- Carl B. Smith
Technical Director -------------------------- Marvin LeDuc
Stage Manager ----------------------------- Emily Francis
Assistant Stage Manager --------------------- Tom Hardy
Orchestra ---------- Amy Ripple, Ora Connors, Aarne Olkkonen
Tickets ------------------------------------ Cecilia Merz
Properties -------------------------------- Barbara Raymond
Publicity ---------------------------------- Jean Bentley
Refreshments ------------------------------- Ethel Dodds

Masks and costumes designed by Bernice Dendel Smith
Wigs built by courtesy of the Laura Jane Beauty Shop

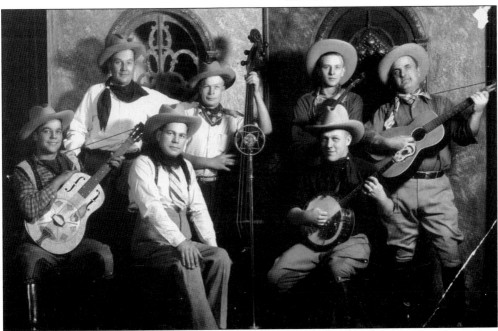

This picture of Michigan Cowboys was taken in the 1930s. Ray Walters is seated to the left of the microphone, and Don Vanderlip and Elmer McDonald are standing in the back row, third and fourth from the left. Walters had a music store in downtown Lapeer. (Courtesy of Marge Schultz and the LCHS.)

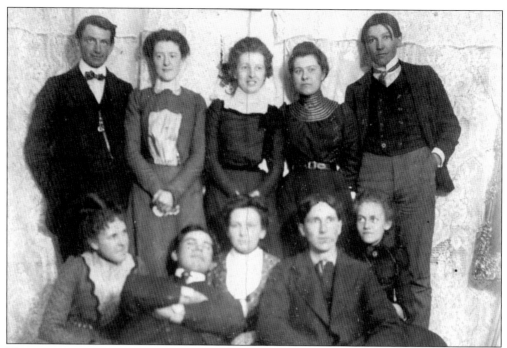

This young group of people entertained the citizens of Hadley with their talents during the early 1900s and performed various plays at the town hall. They are, from left to right, (first row) Saddi Ivory, Duane Patter, Grace Stucker Crankshaw, Kirk Ivory, and Ida Barlenfelder; (second row) Bert Stocker, Edith Stocker, Flora Ivory, Ina Ivory, and George Schoader. (Courtesy of the Ivory family collection.)

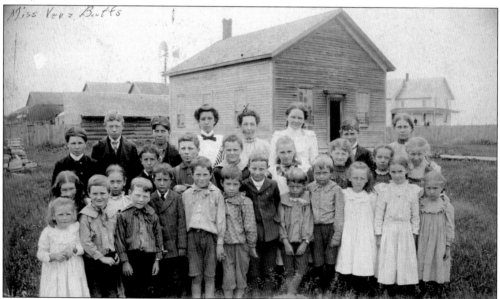

This is a picture of the Elba Bearinger School in 1898. This one-room schoolhouse that comprised the first through the eighth grades was the first school in which Veva Butts taught. To the right of the one-room schoolhouse is a large frame farmhouse, and to the left is a small log cabin. (Courtesy of the LCHS.)

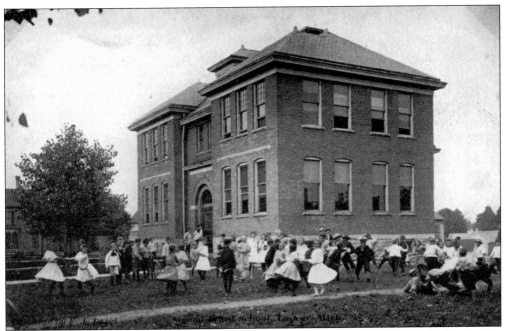

The First Ward School, built in 1873, was located on Pine and Saginaw Streets and continued to be a functional school until 1923. It is presently used as the Apostolic church. The Second Ward School was built in 1898 on Calhoun Street. It was dismantled in 1967, and the grounds were then turned into the parking lot for Baird Newton Funeral Home. (Courtesy of the LCHS.)

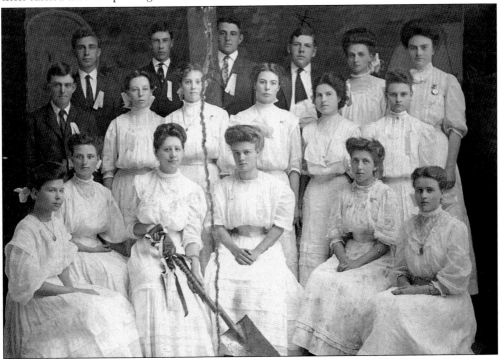

This picture of Morrell Jones's graduating class of 1908 from the Third Ward High School shows the style during this era, including starched white ruffles, ribbons, and bows. (Courtesy of the LCHS.)

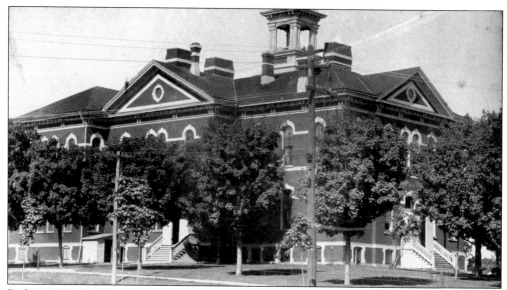

Built in 1875, the Third Ward High School started the first Lapeer County normal school in 1906 in the ward's two upper rooms. Students interested in a teaching vocation could attain a certificate in one year to become a teacher in their district. The name *normal* was taken from Normal, Illinois, which was the first town to begin the teaching program. In 1946, the normal school was abandoned because Third Ward needed the space. The Third Ward was dismantled in 1965. The school bell is on display at the historical society because of Marguerite de Angeli's story in *Copper-Toed Boots*. The story states that Angeli's father put a calf in the school's belfry and tied its tail to the bell rope, and every time the calf moved its tail, the bell would ring. (Courtesy of the LCHS.)

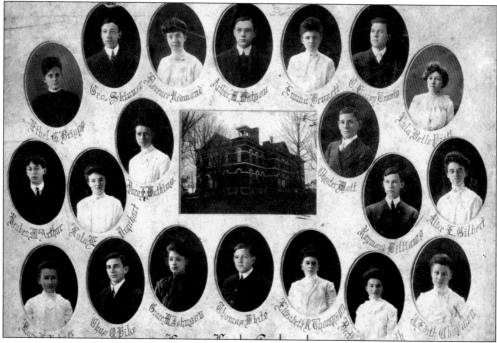

A picture of the Third Ward High School is seen in the center of this picture. This picture was found at a flea market in Odessa, Florida, by Ken Mills of Toledo, Ohio. (Courtesy of the LCHS.)

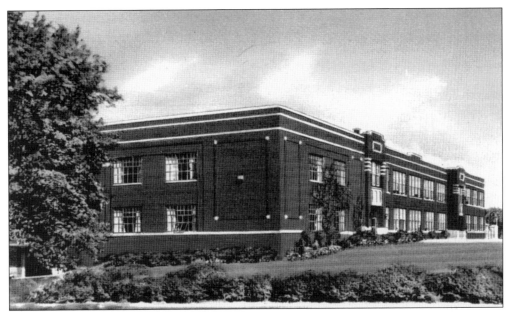

Lapeer High School opened in 1923 and is located at the end of Nepessing Street, next to Genesee Street. It later became White Junior High School. Presently it is known as the White Building, used by the administration, and the school's auditorium is used for community events. (Courtesy of the Best family collection.)

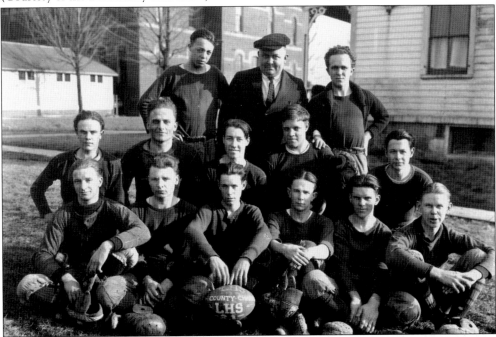

The Lapeer High School football team became district champions during the early 1900s due mainly to Lapeer County's famous coach, Peter Chatfield. Chatfield was Lapeer High School's first full-time coach. He coached all of the school's sports teams and was very successful in both baseball and football. This 1922 picture shows one of Chatfield's successors as coach at the high school. It is uncertain who the coach is. (Courtesy of the LCHS.)

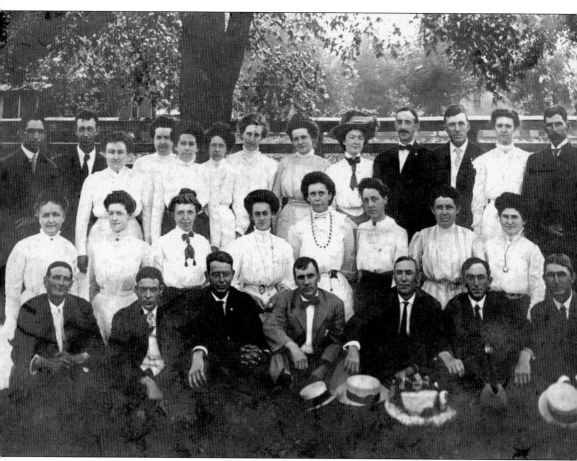

A big moment in Hadley occurred when Mrs. George Grover discovered this picture of her parents at the 1907 Hadley homecoming at the Hadley schoolyard. The people in this photograph are, from left to right, (first row) Bert Stocker (Grover's father), George Proctor, Leslie Suiter, George Phillips, Frank Withey, Dilliam Bullock, and Myron Delano; (second row) Minnie Chamberlain, Edith Townsend Stocker (Grover's mother), Leora Morton Suiter, Una Ivory Bartenfelder, Gazena Middleditch Chapman, Myrtle DeWitt Bullock, Mable Stewart Thiemkey, and Ellen Thompson Michael; (third row) Arthur Sanborn, Earl Ivory, Creta Lamphier Sanborn, Mable Hodgson Mack, Lulu Stewart, Mamie Sweat Withey, Venus Henderson VanKirk, Mabel Smith, Lizzie Rieman, Motier Bullock, Mr. and Mrs. Schank, and Will Thiemkey. (Courtesy of the Ivory family collection.)

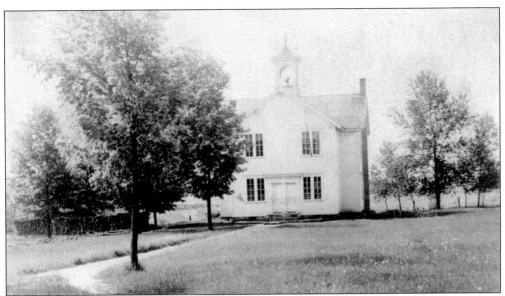

Built in 1872, the Hadley Union School included elementary and high school grades. Students in outlying areas sometimes boarded in town during the week in order to attend the school. In the 1930s, Supt. Orville McCormick had water piped into the school for an indoor toilet. Tearing down the old outhouses and seeing the two paths behind the school building growing over was a happy reminder of America's innovative technology that made everyday life affordable and comfortable. (Courtesy of the Ivory family collection and the Hadley Township Historical Society.)

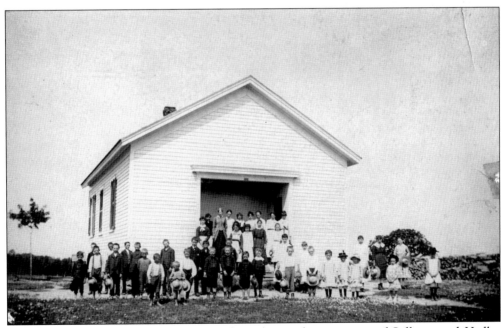

The Hadley McIntyre School was located on the northwest corner of Sullivan and Hadley Roads. Showing a one-room schoolhouse, the photograph probably dates back to the early 1900s and was presented to Nelli Trefield and Earl Ivory by the teacher, Lillie Kenderson. (Courtesy of Betty Ann Ivory.)

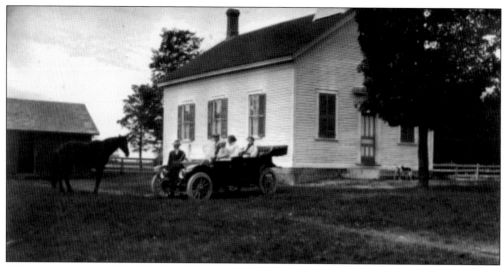

This one-room schoolhouse, located on Baldwin Road, is the Farmers Creek School, part of Hadley Township. The school was built on Copeman land, and the land was leased to the school for 100 years. John Westley Copeman, whom people always referred to as "Wess," is standing by the Model T. The little boy in the car is Lloyd Berger Copeman, Hazel Copeman (Lloyd Groff Copeman's wife) is in the front seat, and Kitty Copeman is sitting in the back seat. Lloyd Groff Copeman is taking the picture. (Courtesy of Kent Copeman.)

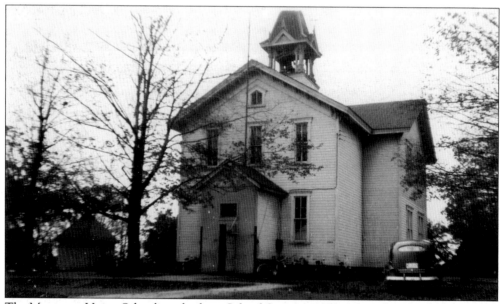

The Metamora Union School was built on School Street in 1875. A large windmill supplied the school with enough power to pump water for the school. However, Blood School, located on Blood Road, was not so lucky. The school had no well or windmill. Every day the students would take turns carrying a bucket of water to the schoolhouse. If that student forgot, everyone went without water that day. During the 19th century, the Metamora Union School housed both elementary and high school students. (Courtesy of the Best family collection.)

The community continued to flourish, and a high school was built in the late 1800s or early 1900s. In *Metamora Among the Hills*, John M. Gregory, superintendent of public instruction, expresses his exultation and attributes Metamora's growth to a blessing of God himself. In a note to the governor of Michigan, he wrote, "Under the benignant care of Almighty God." (Courtesy of the Best family collection.)

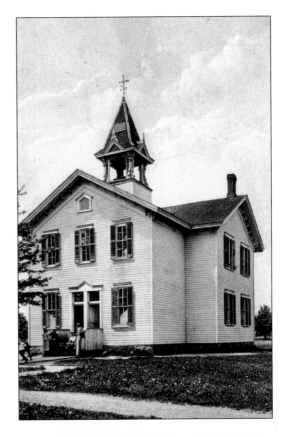

Pictured in this 1945 photograph of Metamora Merchants are, from left to right, (first row) Bob Morse, Jack Morse, Jim Whiteman, Ken Townsend, Fred Thiemkey, Shorty Schenkel, and Buck Townsend; (second row) Bill Hobbins, Bert Baxter, Ralph Hebert, M. D. Ribble, Don Cascadden, Wid Ribble, Bill Skellenger, Joe Brickmeyer, Jack West, Jimmie Morneau, George Townsend, Don Hartwick, and Bob Downs. (Courtesy of the Best family collection.)

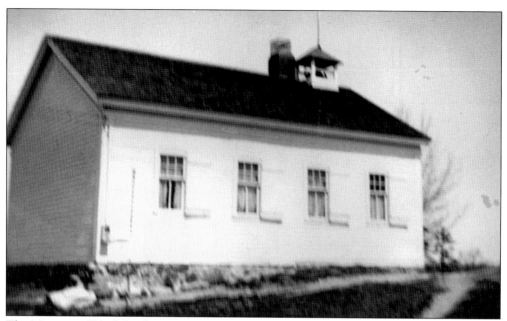

The Metamora Kile School was a one-room schoolhouse that included the first through eighth grades. Students living in rural areas walked to school. When buggies were replaced with cars, one popular recess game was to take a buggy to the top of a hill, tie a rope onto the steering mechanism, fill the seats with students, and free-roll it down the hill. If a tree happened to get in the way, everyone bailed out quickly. (Courtesy of the Best family collection.)

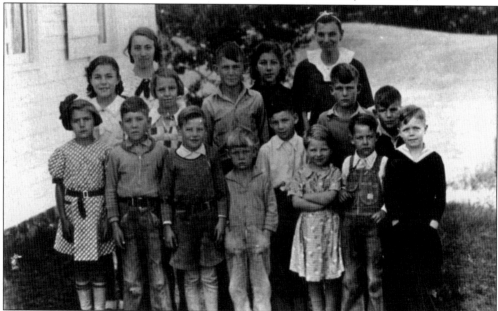

These Metamora Kile School students from Cloe Dudley's 1936 class include six children from the Best family: Harry Jr., Mary Ellen, Lynn, Glenn, Keith, and Harold. Dudley seems pleased, perhaps because of Frank Best's letters, which were delivered by his nephew Harold Best. When the new school season came, Dudley's name had changed to Mrs. Best after marrying Frank Best. (Courtesy of the Best family collection.)

Five

COMMUNITY PRIDE

Nathaniel Greene volunteered for the Civil War on the day he turned 18. He did so to take a neighbor's place in trade for 60 acres of farmland. Greene was wounded once and twice escaped from the Confederates. One escape happened while he was carrying dispatches in enemy territory. He knew he could either be shot or hung. He decided he would rather be shot. He and his companion kicked their horses into a run when the opportunity arose. The Confederate soldiers opened fire and hit Greene in his left shoulder. This did not dampen his sense of integrity when a Union soldier began to take advantage of a Confederate woman; Greene was quick to come to her aid. Greene, a soldier in Gen. William Tecumseh Sherman's army, took no pride in burning Confederate homes, as stated in a letter to his mother, Martha Greene: "Some of our soldiers brag about burning the homes of the confederates. I think it is wrong for them to do so. I ask them how they would like it to have their homes burned over their mother's head." (Courtesy of Edgar Howe.)

On April 6, 1917, the United States declared war on Germany, and World War I forced Americans to realize that the United States could no longer ignore the rest of the world's problems. Americans marched to the tune of George M. Cohan's "Over There" while lining up before their draft boards. Pictured here are, from left to right, Mr. Erickson, Mr. Wheaton, Mr. Yule, and Clyde Weir resting before their barracks. (Courtesy of the LCHS.)

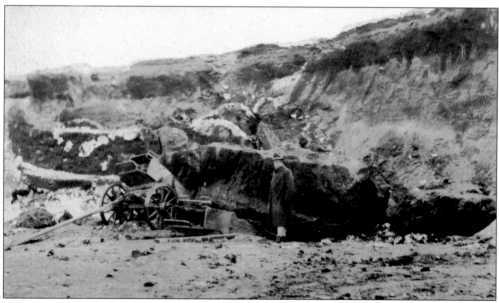

Not every soldier died in the field of battle. One soldier lost his life and two others were seriously injured when an overhanging cliff of gravel gave way on February 10, 1918, at a gravel pit at Camp Custer. Pvt. Clyde Weir is in the picture. (Courtesy of the LCHS.)

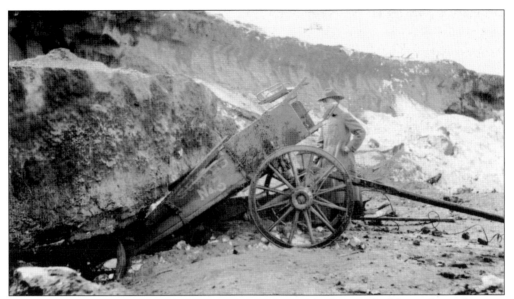

To complete the quota for Camp Custer, Lapeer County had to send additional men because those sent earlier failed to pass the army's physical fitness tests. It is said that the tests at the Lapeer Opera House Block, or White Building, resulted in 153 examinees passed, 11 rejected, and 52 referred for further examinations. (Courtesy of the LCHS.)

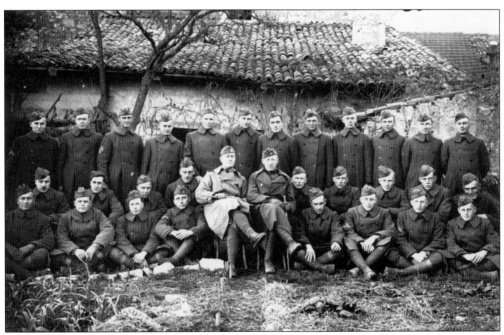

Airplanes were used for the first time during World War I to bomb soldiers and civilians. Still, much of the war was hand-to-hand combat, and in this 1918 picture taken in France, American infantrymen, or doughboys as they are called during the war, are visible. Determined to get their sons, daughters, and sweethearts back home, American factories worked extra shifts to supply doughboys with needed supplies. (Courtesy of the LCHS.)

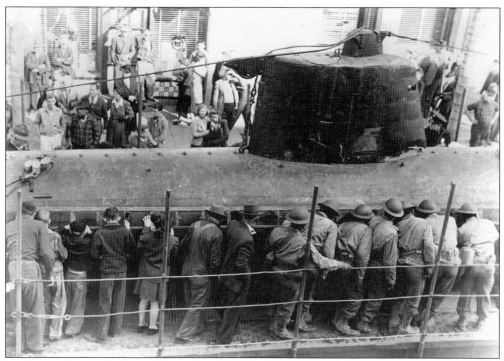

Tanks, trucks, and submarines were produced on assembly lines in record numbers. This submarine was displayed in Lapeer during the bond drive of World War I. A closer view of the submarine displays the vastness of this floating city in the sea, and Lapeer residents and many on-leave infantrymen take in an eyeful of this working torpedo machine. (Courtesy of the LCHS.)

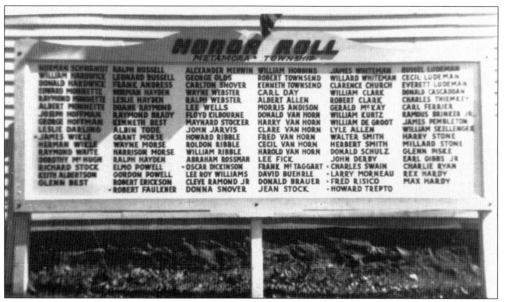

Many cities and towns across the Lapeer area were proud of the men and women willing to donate their talents and lives to keep America safe for their loved ones. This photograph shows Metamora's honor roll of World War II veterans. (Courtesy of the Best family collection.)

Cities and towns across the nation contributed to the scrap drive during World War II by donating scrap materials such as metal and rubber in order to aid in the war effort. The county of Lapeer donated the courthouse's Civil War cannon for the World War II scrap drive. (Courtesy of Don and Pat McCallum.)

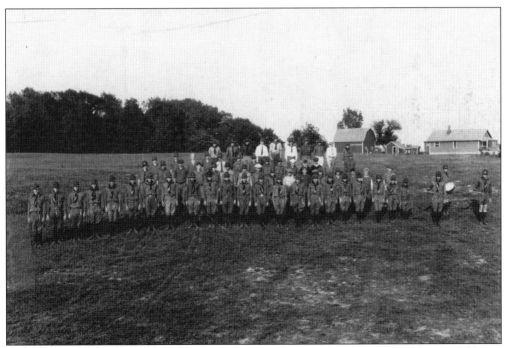

On June 9, 1832, the first "swing out" for Lapeer schools brought the school band and several hundred pupils marching along with the Boy Scouts through the business districts followed by a tree-planting ceremony at the high school. Oftentimes what the boys learned from their Scout leaders helped equip them for adulthood. (Courtesy of Bob Markley and the LCHS.)

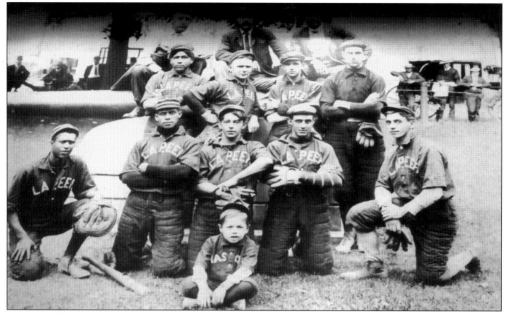

This picture is of the Lapeer city baseball team sitting on the Civil War cannon on the courthouse lawn. Peter Chatfield is seen in the center row on the left. His father, William Chatfield, enlisted in the 10th Michigan Volunteers and served in the Civil War as an example to other Native Americans to take up the ways of the white man. William was allowed to move back to Lapeer in the late 1870s. Peter was born on July 30, 1874, worked for Bostick Stove Works, and attended Carlisle Indian College in Pennsylvania, where he became a football star, baseball player, and a member of the college band. (Courtesy of the LCHS.)

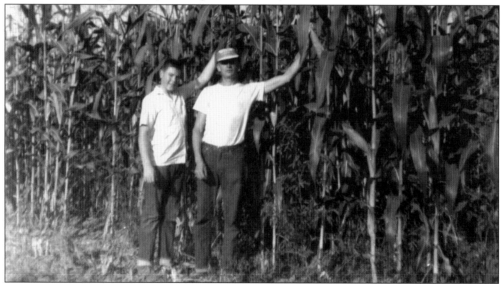

In August 1929, this large field of corn stood on Casey and Thornville Roads and won first prize at the Imlay City Eastern Fair Grounds during the 4-H fair. The 4-H motto was Make the Best Better, and anyone between the ages of 10 and 20 could join and "learn to do by doing." A bountiful crop as well as a shiny blue ribbon was given to 16-year-old Curtis Middleton (pictured with a hat) for his hard work that season. (Courtesy of Curtis Middleton.)

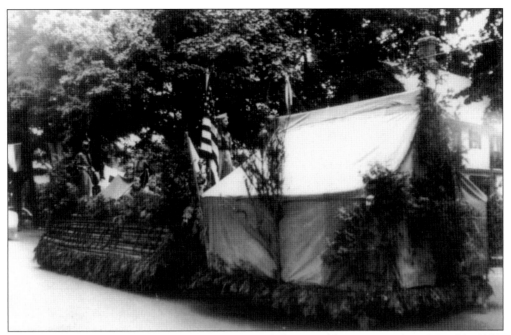

Along with the Boy Scouts, the Grand Army of the Republic, organized on May 28, 1883, performed in many parades like this one and held marches to Mount Hope Cemetery to decorate the graves of soldiers, such as the grave of Capt. J. H. Turrill, who was killed while leading his soldiers to Antietam during the Civil War. (Courtesy of the LCHS.)

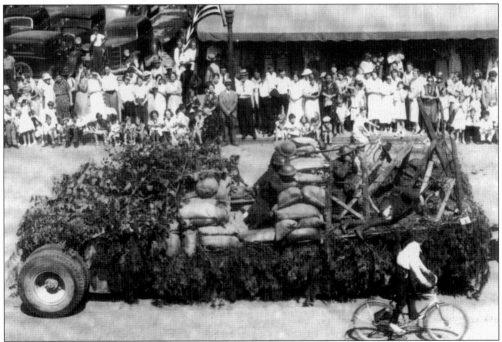

After World War II, the American Legion Post 16 formed. It won first prize in the 1937 Lapeer Days parade for its authentic float depicting the uniforms and firearms of World War II veterans. (Courtesy of the LCHS.)

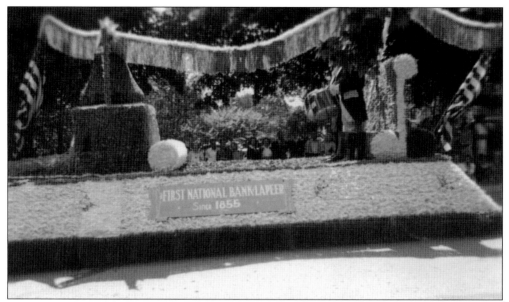

This depiction of the Revolutionary War by the First National Bank of Lapeer is complete with the Liberty Bell. Perhaps the bank's depiction served a dual purpose in this Lapeer Days parade, providing a small tribute to its ancestor Deacon Enoch White, who was a lieutenant in the Revolutionary War army. It was the family of his son, Enoch White Jr., who came to Lapeer. (Courtesy of the LCHS.)

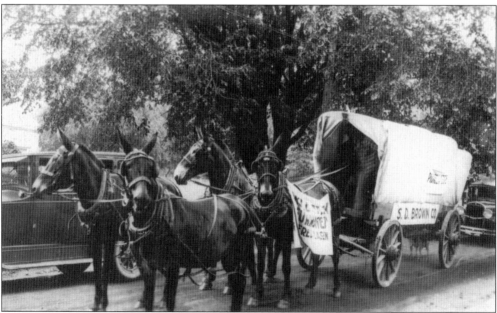

The S. D. Brown Company bought the building located on Nepessing Street from the Methodist church in the late 1800s. S. D. Brown opened up a furniture store and later turned it into a funeral parlor. He appeared in many of the Lapeer Days parades and took pride in his matching team of mules who never minded walking alongside the modern age of technology. (Courtesy of the LCHS.)

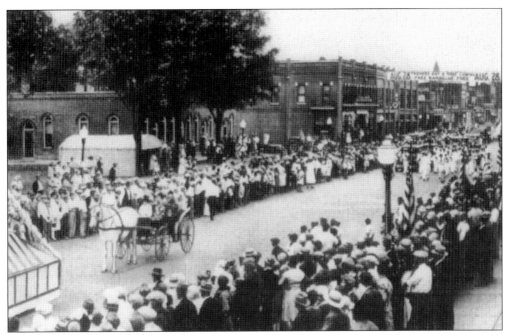

The day is August 28, 1930, and Main Street is crowded with Lapeer residents out to view the Lapeer Days parade, which included a glimpse of a horse and buggy, a romantic reminder of bygone days. (Courtesy of the LCHS.)

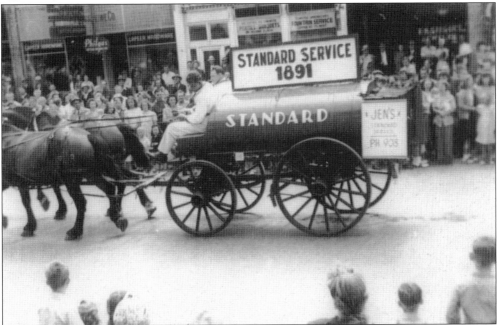

A horse-drawn Standard Service tank ironically pulls this gasoline tank dated 1891. Oil was first used to heat many factories, and in the early 1900s, Standard Oil began to furnish gasoline when the automobile industry began to flourish. Ford's new mode of travel was, more often than not, unreliable back in the early 1900s and brings humorous memories of the past to many old-timers of those years during this 1940 Lapeer Days parade. (Courtesy of the LCHS.)

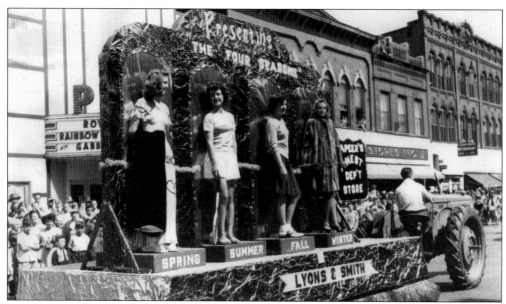

From evening gowns to mink coats, Lyons and Smith Department Store in Lapeer represents the four seasons with eight models, four on each side of the float, demonstrating the department store's finest clothing. Summer was represented by Joyce Collins and Carol Stiles, fall by Helen Green and Lucille Patten, winter by Doris McBride and Marilyn Roberts, and spring by Letha Otting and Nadine Stewart. This float won first place in 1946. (Courtesy of the LCHS.)

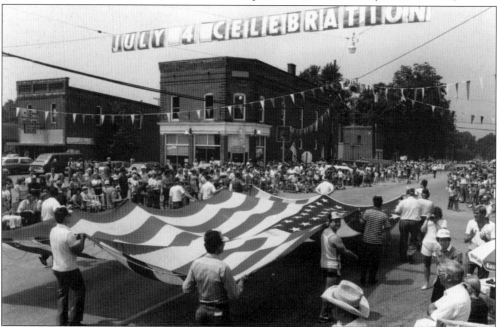

Parades are one of the most popular ways that Americans celebrate the Fourth of July holiday. In this 1975 picture of Hadley's Fourth of July celebration, the community has turned out in record numbers to proudly carry this large flag down Main Street in a prelude to the barbecues, ice cream, and musical shows to be enjoyed throughout this happy occasion. (Courtesy of the Hadley Township Historical Society.)

Six

HERITAGE

Alvin Nelson Hart was born on
February 11, 1804, and educated in the
academy at Sharon, Connecticut, and
the college at Amherst, Massachusetts.
He was the first settler of Lapeer
and platted the village of Lapeer on
November 8, 1833. He also built the
present Lapeer Courthouse. Alvin
Nelson and Charlotte Hart had nine
children; however, three died young,
and Charlotte died in August 1846.
Their sixth child, Rodney G. Hart,
born on January 10, 1831, was the first
white male child to be born in Lapeer
County and was the only member
of the family to remain in Lapeer
after the others moved to Lansing. In
1835, Alvin Nelson Hart was elected
representative to the state legislature.
In 1843, he as elected state senator
and in 1846 elected the first judge of
Lapeer County. In 1870, he was elected
representative of Ingham County and
aided in obtaining the money for the
new state capitol, which he suggested
should be relocated from Detroit to
Lansing. Alvin Nelson Hart died at
age 70 in Lansing on August 22,
1874, and was buried at Mount Hope
Cemetery. (Courtesy of the LCHS.)

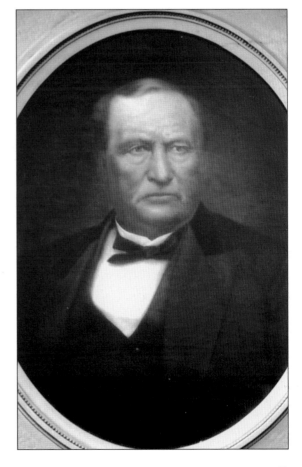

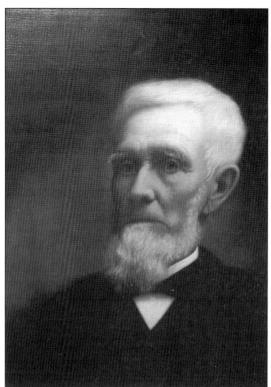

Phineas White was born on May 2, 1810. When Phineas was 17, his father, Enoch J. White, died, and Phineas became head of the household. Phineas belonged to the White banking firm and the old stage line from Lapeer to Pontiac. Brothers Phineas and Capt. Henry K. White were killed when hit by a train in Lapeer on May 12, 1898. Nearly 1,000 attended the burial at the Mount Hope Cemetery. (Courtesy of the LCHS.)

Judge W. M. Stickney of Lapeer was a man who loved his home and his wife. It was said that he knew how to make his home a happy place to live. Daniel Webster was once quoted, "Good lawyers work hard, live well and die poor." Stickney was an exception because he was a good lawyer, and he worked hard, lived well, and did not die poor. (Courtesy of the LCHS.)

A fine and honest man, the Honorable John T. Rich was born on April 23, 1841, and was the only Lapeer County resident to become governor of Michigan. During his term as governor, he was instrumental in forming a committee to decide the location of the Lapeer State Home and Training School. He was highly esteemed by the people of Lapeer and considered "a man of great integrity and one of Michigan's best governors." He died on March 28, 1926. (Courtesy of the LCHS.)

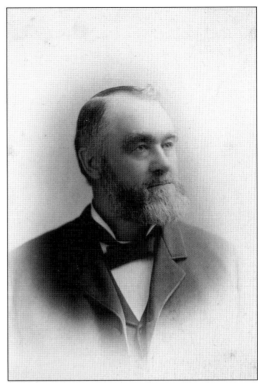

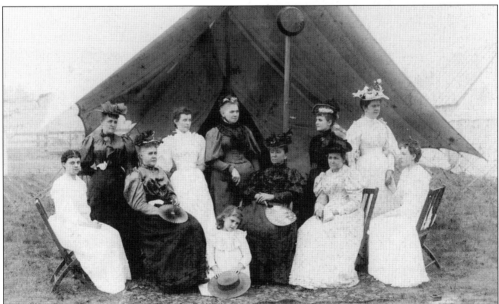

Governor Rich's wife, Lucretia Winship, is dressed in black and sitting in the center of the ladies beneath the tent that was put up for the ladies' comfort. Victorian dress allowed ladies little comfort from the heat, with long sleeved blouses and corseted waistlines with layers of petticoats. It is no wonder that these ladies look a little uncomfortable. Lucretia Winship Rich was an avid supporter of her husband's policies and positions. Her death in 1912 was a great loss for Governor Rich. (Courtesy of the LCHS.)

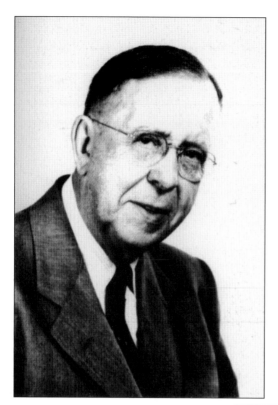

Louis C. Cramton was born on December 2, 1875, in Hadley Township and graduated from Lapeer High School in 1893. He became nationally known and served for more than 50 years in the public arena. He was a staunch supporter of the Prohibition movement. He authored Michigan's Fair Employment Practices Act and led in establishing the national park system. (Courtesy of the LCHS.)

Peter Chatfield, also known as Chief Gray Hawk and the last of the Nepessing tribe, lived on a small farm near Lake Pleasant. After his retirement, Lapeer High School issued a football award in Chatfield's name annually to the team's best lineman. He followed the Christian teachings of the Liberty Street Gospel Church. Rev. Frank S. Hemingway conducted the services upon Chatfield's death in August 1948. The Chatfield School, founded in 1997, was the first charter school in Lapeer County. The school was not officially named after Peter Chatfield. (Courtesy of the Chatfield School.)

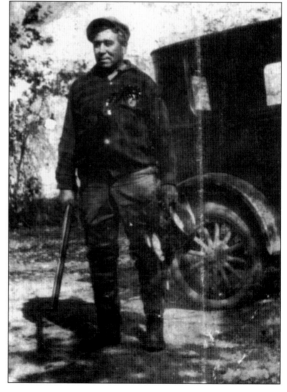

Marguerite de Angeli was born on North Main Street in Lapeer on March 14, 1889. When she was two, her family moved to Chicago; however, her parents did not care for the noise of the saloons and returned to their home in Lapeer. In the spring of 1903, when Angeli was 14, they moved to Philadelphia. (Courtesy of the Marguerite de Angeli Library.)

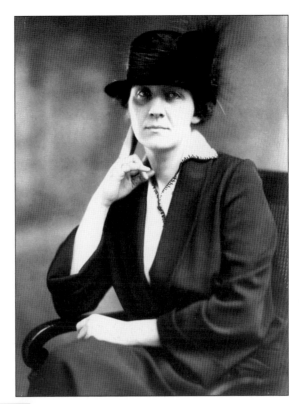

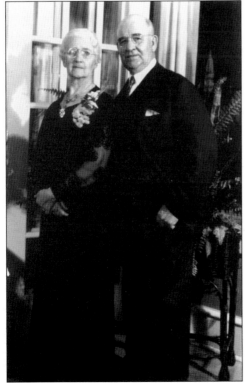

According to *Butter at the Old Price*, Ruby Lofft, Angeli's mother, heaped not only nourishing food but encouragement onto her daughter's plate. "You can do anything you really want to do," she told Angeli. Angeli's father, Shadrach George Lofft, was a major influence in Angeli's love for drawing and her inspiration for *Copper-Toed Boots*, which told about her father's exploits growing up in Lapeer. (Courtesy of the Marguerite de Angeli Library.)

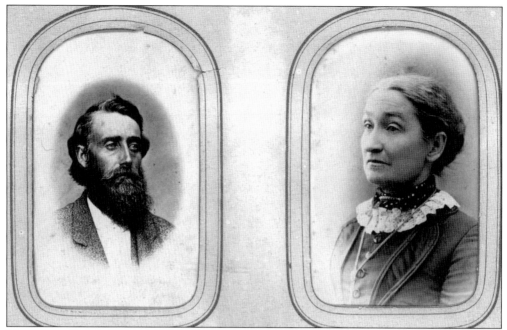

Marguerite de Angeli's mother, Ruby, is descended from the first William Tuttle (left) who came from England to America in 1632. The family name was first spelled "Tut-Hill" and means "the hill watching." Ruby's mother was Eunice Hough (right), a descendant of Edward Hough of Chester County, England, who came to Massachusetts in 1640. (Courtesy of the Marguerite de Angeli Library.)

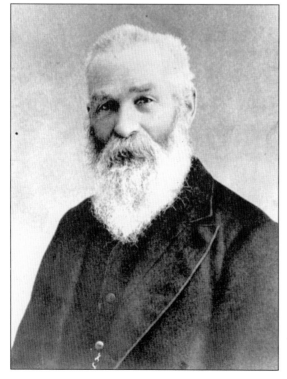

Angeli's great-grandpa Sloan (at left) was from Northern Ireland and settled in Goderich, Ontario. Maggie Sloan met and married de Angeli's grandpa Lofft on September 6, 1862, in Goderich, Ontario, and moved to Lapeer shortly afterward (they are Shadrach George Lofft's mother and father). Great-grandpa Sloan was buried at Mount Hope Cemetery in Lapeer near the Loffts' grave site. (Courtesy of the Marguerite de Angeli Library.)

Nina, Marguerite de Angeli's older sister, was a frail child who survived childhood diseases, married, and became Nina Price. However, a bout with pneumonia caused her sudden death on April 1, 1918. A lighthearted optimist, Nina could not help but play an April Fools' joke on Marguerite that fateful day, then passed away in her sleep. Marguerite would face yet another heartbreak in her life when her daughter died much the same way. (Courtesy of the Marguerite de Angeli Library.)

In *Michigan's Marguerite de Angeli*, Angeli is quoted, "So often I have tried to discover what it is that impels us to write or to draw." Marguerite de Angeli began her journey as a pioneer of children's books by illustrating books for prominent authors. For *The Door in the Wall*, Angeli won the Newbery Medal, and in 1961, she won the Lewis Carroll Shelf Award, but *Copper-Toed Boots* won her the devotion of Lapeer. (Courtesy of the Marguerite de Angeli Library.)

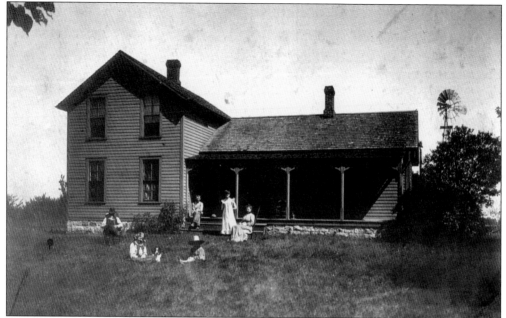

In 1879, Robert and Lavina Davis purchased 40 acres of land from Jonathan Grey for $2,000 and then, over a period of time, purchased an additional 50 acres for prices varying from $1 to $1,800, eventually absorbing 265 acres. Robert and his son Frank quit their jobs at the sawmill and became tillers of the land. This house, which they built around 1890, was where their families took time to enjoy a peaceful evening after a hard day's work. (Courtesy of the Davis family collection.)

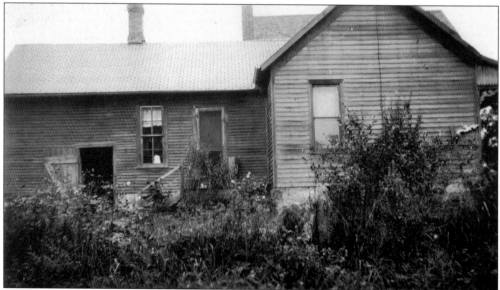

Frank Davis's son, Kenyon, married Mildred Davenport and had a daughter, Mary Ellen. They lived in this house, across from Frank and Robert's house. Money was tight and there was not enough to afford paint for the house and little time to mow the lawn after tilling the fields for 10 hours a day. After a profitable season in 1929, Frank, Robert, and Kenyon could afford to buy paint for their houses. (Courtesy of the Davis family collection.)

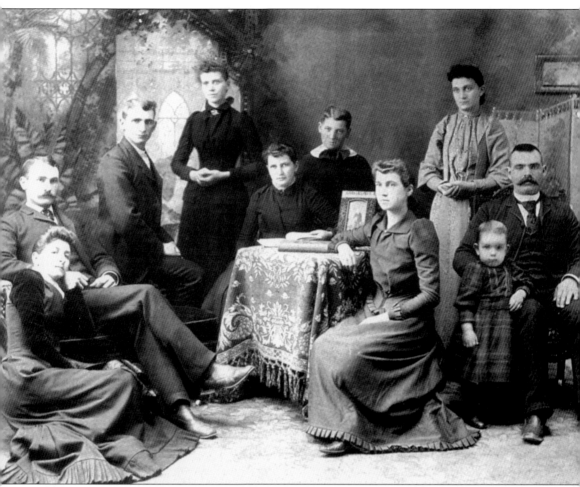

During those early land purchase years, Robert and Lavina had six children: Frank, Nelson, Elizabeth, Blanch, Bernice, and Carl. Frank married Clara (Carrie) and had three children: Kenyon, Horace, and Muriel. Muriel married Ralph Davenport. Robert and his son Frank became dedicated farmers, followed by Frank's sons, Kenyon and Horace. Kenyon married Mildred Davenport, Ralph Davenport's sister, and had one daughter, Mary Ellen. Horace married Beatrice Barber and had four children: James, Frank, Darwin, and Jean. Although all of Kenyon's and Horace's children worked on the farm, none became farmers as adults. The Davis Brothers Farm located on Davis Lake Road in Lapeer County is now a farm museum and offers the public educational tours and exciting venues of farming activities throughout the summer months. (Courtesy of the Davis family collection.)

During the winter months, ice cutting was just one of many chores. Ice was cut in square chunks, packed in sawdust, and stored in an insulated shed for summer refrigeration of the family's produce. This photograph shows a pair of horses hooked up to a hand plow and one person fishing to hook another slab of ice to load onto a nearly full wagon. (Courtesy of the Davis family collection.)

Horace Davis smiles at the wheel of his put-and-take engine. But he is not as happy as his dad, Frank, third from the left, proudly showing off before his friends his son's accomplishments. Horace made this implement himself, and it is still a part of the Davises' working farm to this day. (Courtesy of the Davis family collection.)

In the early 1900s, the Davis family was well known for their modern concept of farming. The Davis brothers purchased their first McCormick-Deering tractor and eagerly put it to the test. In this photograph, the Davis brothers are struggling to get the tractor unstuck during an early spring thaw in the thick mud during the spring of 1929. (Courtesy of the Davis family collection.)

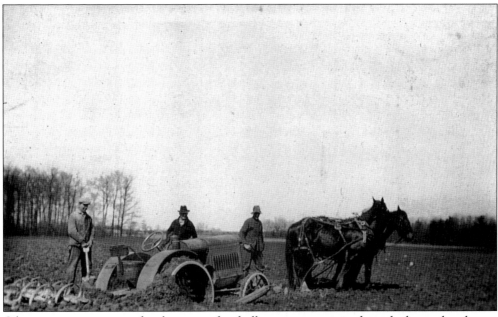

Oftentimes tractors proved to be more of a challenge to maneuver through the mud and snow than the power and convenience was worth. The heavy machines sank easily into the wet soil, and a team of horses always stood by to rescue them. (Courtesy of the Davis family collection.)

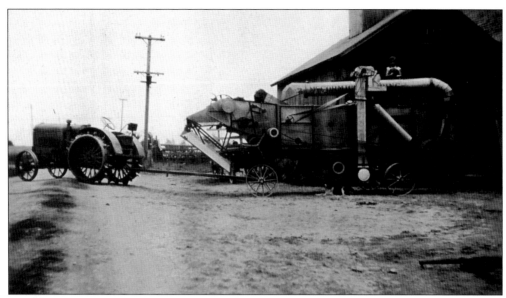

In the early 1930s, the McCormick-Deering thresher helped many farmers speed up the harvesting process. Many farmers purchased and shared equipment that they could not afford to purchase singularly. Here eight-year-old Mary Ellen Davis (later Heckman) puts a finger to her new bib overalls, which were quite the rage then. (Courtesy of the Davis family collection.)

Lloyd Groff Copeman, the son of John Westley Copeman, was born in Hadley Township in 1881. Lloyd attended a one-room schoolhouse in Farmers Creek and displayed his "inventive genius" talent as early as age 10. Little did his father realize when this photograph was taken the priceless gifts his son would contribute to the welfare of his fellow man. (Courtesy of Kent Copeman.)

Lloyd Groff Copeman graduated from Lapeer High School and went to Michigan State University, where he pursued a course in mechanical engineering. Copeman was expelled repeatedly from each school he attended. This did not discourage the young man from inventing nor did it discourage him from pursuing his high school sweetheart, Hazel Berger, to Washington. They were married in September 1904. This photograph shows Copeman during the Christmas of 1916 at age 35. (Courtesy of Kent Copeman.)

Copeman invented the Copeman Electric Stove in 1912; however, in 1913, and the average house was not wired for electricity. Although Copeman sold his patent to Westinghouse, his first stove can be seen in the Sloan Museum in Flint. The Copeman Electric Toaster proved the forerunner of the pop-up toasters of today. Another of Copeman's inventions was the Copeman Lubricating System. Pictured here is a 1918 advertisement from the Literary Digest. (Courtesy of Kent Copeman.)

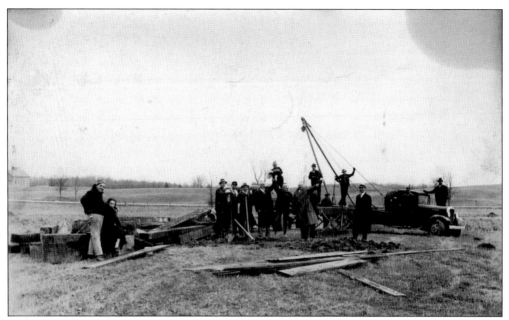

The first natural gas well found in Lapeer County was the Halpin Well off Baldwin Road in Hadley Township in 1935. Lloyd Groff Copeman is seen in the short coat; his hat is raised in the air. He and his colleagues were unable to reach the stratum that would produce a heavy flow of Antrim-level gas. His friends Henry Ford, the Fisher boys, the Dodge boys, and J. D. Dort would often offer their opinions. (Courtesy of Kent Copeman.)

Copeman was a nature lover and great outdoor enthusiast, and one of his inventions came about during a hunting expedition. The story is told that Copeman found that water had frozen on his wading boots, and when he cracked the ice, the idea of rubber ice trays evolved. Royalties from the rubber ice tray netted more than $1 million and became his biggest money-making patent. (Courtesy of Kent Copeman.)

In later years, Michigan State University offered Copeman an honorary doctorate, which he refused, stating, "When the degree would have done me some good you wouldn't give it to me. Now I have little desire to accept it." E. W. Atwood and John M. Kisselle, his patent attorneys from Detroit, were his trusted friends. Copeman often credited his successful business enterprises to them. Copeman continued to do what he loved, to invent, until his death in 1956. (Courtesy of Kent Copeman.)

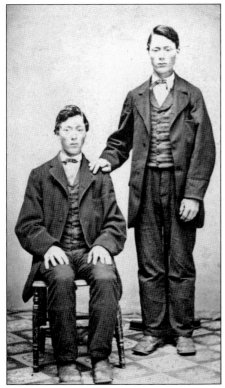

Ellery and Elwell were the identical twin sons of William Ivory and Sarah (Jones) Ivory. William was farming in New York for his brother John. John moved to Benton Harbor, and both brothers eventually settled in Hadley. Out of a family of nine siblings, everyone in the family ended up leaving Upstate New York but one. (Courtesy of the Ivory family collection.)

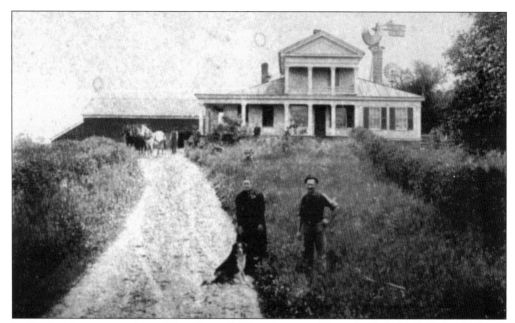

In 1888, visitors came seldom if hardly at all. Ellery Ivory and his wife, Ophelia E. (Schock) Ivory, take a moment to welcome their company at their farm on Steward Road in Hadley. A team of three horses stand unhitched in the drive and the wagon drivers at the top of the hill, too, wait to see who the visitors may be. Fourteen-year-old Emma Hardwick Broome stands in front of the family's wide porch and peaks out curiously. (Courtesy of the Ivory family collection.)

This is an 1885 picture of Ophelia and Ellery Ivory with their seven-year-old son, Earl. Earl was their only child and became a farmer like Ellery. Ellery owned one of the first threshing machines in the area. To supplement the family's income, he would harvest the neighbors' wheat. The farms were always a distance apart, so he often spent the night. Earl died in 1947 from congestive heart failure after working all day at a neighbor's barn. (Courtesy of the Ivory family collection.)

Built in 1854, the Ivory barn burned down and was replaced in 1886. The Ivorys bred Jersey and Holstein cows. Their Jersey cows' milk was thicker, and it was easily made into cream while the Holstein cows just made milk. Using their separator, the Ivorys would separate the Jersey cows' milk from the cream. Then they would take the milk in cans to Goodrich, where it would be shipped to Detroit, and take their cream to the Hadley Creamery to be made into butter. (Courtesy of the Ivory family collection.)

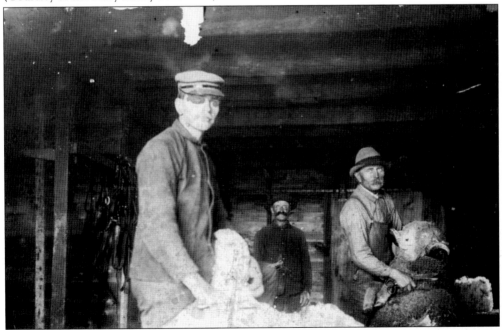

The Ivorys raised sheep as well as cows. Ellery Ivory always hired sheep shearers in the spring to shear his sheep. The price was reasonable, and they could shear a sheep twice as fast as Ellery. Ellery Ivory is standing to the right, ready with another sheep for the shearers. (Courtesy of Betty Ann Ivory.)

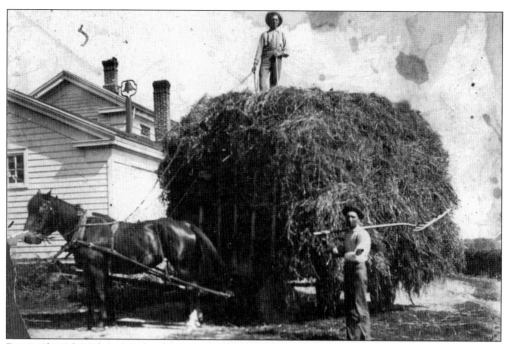

Pictured in this photograph, the men are hauling a wagon heaped with hay to be tossed loose into the barn loft to feed the livestock. The bell just over the framed building was rung to bring the men in from the fields for supper and dinner. (Courtesy of Betty Ann Ivory.)

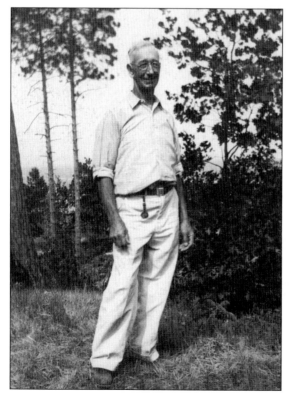

Earl Ivory had four children: Gertrude, Malcolm, Irene, and Elaine. Earl became president of the Hadley Citizens Bank, sold insurance and oil leases, and was justice of the peace. His son, Malcolm, whom most of his friends knew by Mike, became justice of the peace and trustee of the township. (Courtesy of Clinton Ivory.)

This picture of Earl Ivory's daughter Gertrude shows four generations: great-great-grandmother Margaret Voakes, baby Gertrude, mother Florence Hardwick Ivory, and grandmother Anna Voakes Hardwick. (Courtesy of Betty Ann Ivory.)

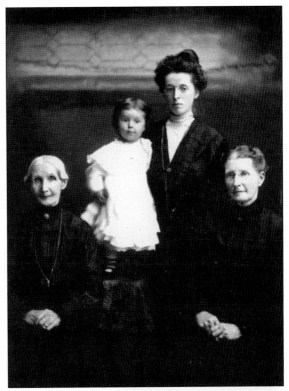

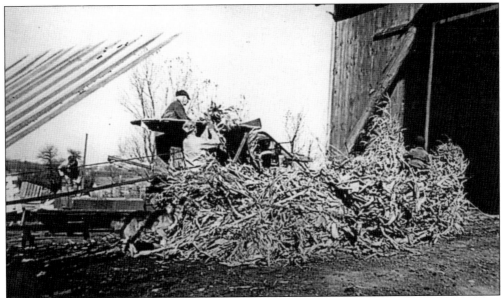

Malcolm Ivory's two sons, Clinton and David, tackled the industrial age of farming rigorously. "They were always planting their tractors," explains Betty Ann Ivory, "trying to grow more." In this 1942 picture, Biz Pierson uses the buckrake to take the bundles of cornstalks gathered off the field and pushes them toward the corn husker where Earl feeds it into the husker. The corn husker will then remove the husks from the ears. The cornstalks will then be blown into the black tube onto the hayloft and the corn will go into a corncrib. (Courtesy of the Ivory family collection.)

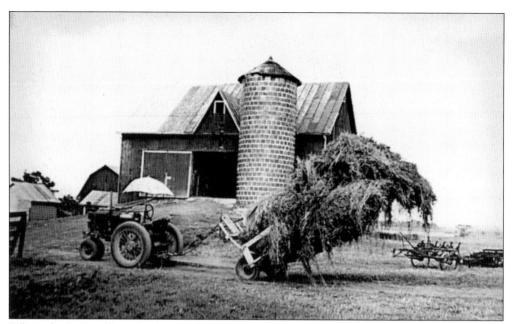

When the Ivorys' dairy herd exceeded 50 heads of cattle, Clinton and David Ivory extended their 300 acres of land by leasing 1,200 more. The tractor waits with an umbrella over it to help shade Clinton from the heat in the fields, and the buckrake loaded with loose hay taken off the field is ready to be carried into the hayloft. "Never had a bail of hay till 1958," explains Clinton. (Courtesy of Clinton Ivory.)

These 10,000-bushel bins show the holding tank, which is the small cone-shaped structure, where the corn or soy beans are placed until they become dry. The dryer is the square compartment located just below the cone. When asked about farming, Clinton Ivory says, "You're born and bred into it." The unpredictability of weather, economy, and life in general are summarized in Ivory's outlook on farming: "You've got to have a few bad years to appreciate the good years!" (Courtesy of the Ivory family collection.)

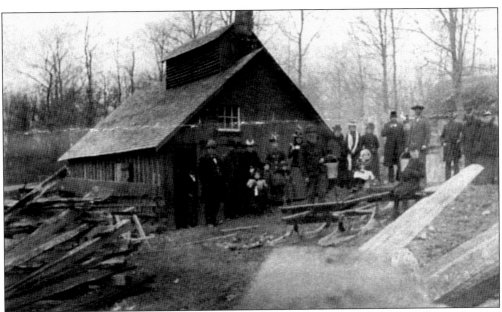

The Bullock Farm, founded in 1857, is located on Lippincott Road in Elba Township and is still owned by Bullock family. It was a large dairy farm and productive apple orchard. The group photographed in front of Albert Bullock's sugarhouse includes Lottie Jones, Ethyl Bullock, Sarah Jane Bullock, Albert Bullock and wife Alice Bullock, Mildred Jones, and Kenneth Bullock. (Courtesy of Norm Bullock.)

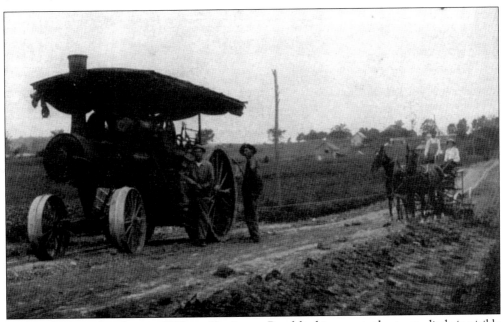

In this photograph, taken in 1913 on Lippincott Road looking west, the town ditch is visible in the background. George Stock is standing alongside the steam engine. A Mr. Truax is by the back wheel, and Albert Bullock is driving the horses on the road grader. Kenneth Bullock is sitting on the seat beside him. The engine was George Stock's Port Huron threshing engine. (Courtesy of Norm Bullock.)

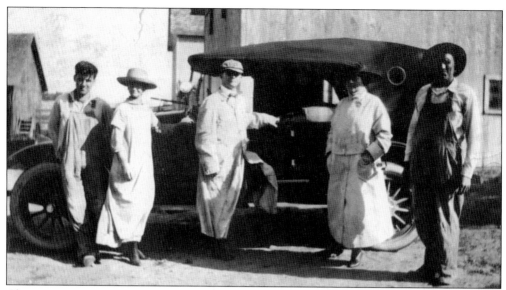

Clarence W. Greene, a graduate of Michigan State Normal School, grew up in Hadley at Greene's Corners. As a professor of physics during the later part of World War II, he designed the instruments and conducted the tests of the units used by the Manhattan Project in the final assembly of the atomic bomb. Greene published a book called *Life at Greene's Corners*, which is a true story about the incidents that occurred in Greene's Corners from 1860 to 1920. This photograph shows, from left to right, Archie Howe; Clarence's sister, Lucy; Clarence Greene; Clarence's wife, Bertha; and Lucy's husband, Edgar Howe. (Courtesy of Edgar Howe.)

Edward Howe purchased Nathaniel Greene's home around 1900. The windmill in the back of the house was installed in 1903 and provided the Howes with running water that was pumped to the second floor for the family's flush toilets. (Courtesy of Edgar Howe.)

Here is a picture of Nathaniel Greene at age 90. From left to right are Archie Howe (Edgar Howe's son), Archie's son, Edgar Howe (who was 10 years old at the time), Nathaniel Greene, and Nathaniel's son-in-law Edgar Howe. Greene's father, whom Greene's Corners was named after, was a second commander of the army during the Revolutionary War. Greene's Corners is located a mile west of Hadley, on the northeast corner of Greene Cemetery. (Courtesy of Edgar Howe.)

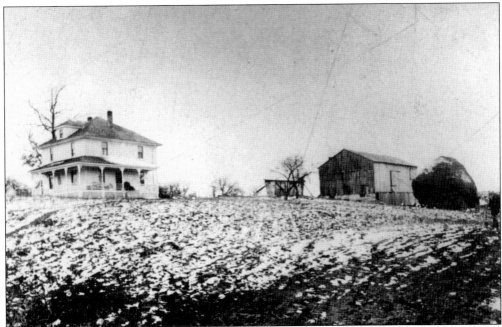

In 1909, Harry Best and Mary (Rossman) Best purchased over 500 acres in Metamora. They raised their seven children there, and together the family raised everything from potatoes and wheat to cows and chickens. Their dairy operation was a seven-day-a-week job with no vacations. (Courtesy of the Best family collection.)

When the alfalfa and clover began to bloom, one of the Best family members would hitch up his team of horses and cut the hay with a five-foot-long sickle. Then with a dumb rake, he would rake the hay into windrows and place it into cocks like these, facing north and south, so the hay could receive the best sunlight to dry. When it was completely dry, he picked up the bundles with his team, as seen here. (Courtesy of the Best family collection.)

Potatoes became a profitable income for the Best family, and acres of potato crops lined the hills on the Bests' farm. In this photograph, a team of horses makes its way down the rough ground of the field, picking up the crates of potatoes ready for market. Horses remained the most prominent source of power used on the farm until the early 1940s. (Courtesy of the Best family collection.)

Sixteen-year-old Harold Best takes a moment to rest beside a basket full of fresh-picked potatoes. Born in March 1925, he would choose farming as his occupation and dedication as his passion, becoming the Metamora Township supervisor for 20 years, Lapeer County road commissioner for 30 years, a member of the Lapeer County ambulance board for 20 years, a Boy Scout leader, a stamp collector, a sports fan, and a history buff, carefully preserving Metamora's history for future generations to enjoy. (Courtesy of the Best family collection.)

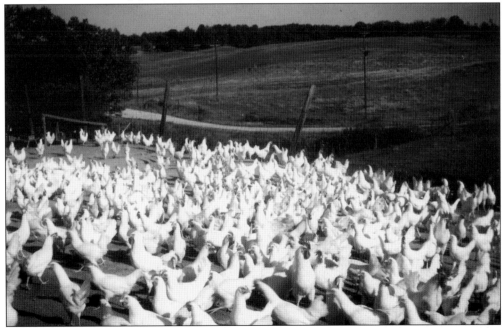

Chickens were one of the main produce on the farm. With the help of Metamora's post office, every spring the Bests would order around 700 baby chickens and have them delivered. In this photograph are the 700 mature chickens enjoying some sunlight. (Courtesy of the Harold Best collection.)

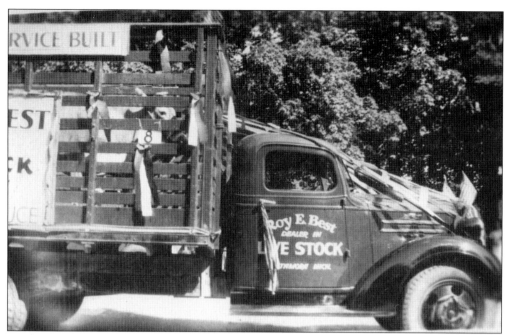

As the nation became more industrialized, so did the farmer. Roy Best began venturing out into other venues, creating new means of income. Best began a livestock business by becoming a modern-day trail boss who would collect the farmers' cattle and haul them off to market. (Courtesy of the Best family collection.)

Until the early 1940s, horses were the main source of power on the farm. As equipment became more mechanized and affordable and the transportation of produce became more efficient, farmers began expanding their product line and profits. Today the farmer's role has become ever more vital to every American. Not only will he continue to supply food, but heating and automotive fuels as well. (Courtesy of the Best family collection.)

Seven

HORSES

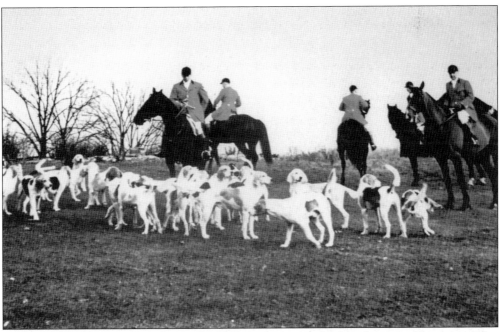

Foxhunting began in Europe during the 1700s with mounted riders chasing wild quarry with a pack of trained hounds. The sport began due to an overpopulation of foxes. A farmer's family and livelihood depended on his chicken, poultry, and lambs. Hence, the sport of foxhunting evolved. The first record of hounds being imported to America for foxhunting was in 1650 by Robert Brooke of Maryland. By the early 1700s, foxhunting had spread to Virginia and neighboring colonies. George Washington was an ardent foxhunter and owned his own pack of hounds. The sport has not changed drastically from its early deportation. The noticeable difference of British hunts versus American hunts is that the American emphasis is on the chase and not the kill. The Metamora Hunt Club located in Lapeer County is one of oldest of the three hunt clubs located in the state. (Courtesy of Gene Lasher.)

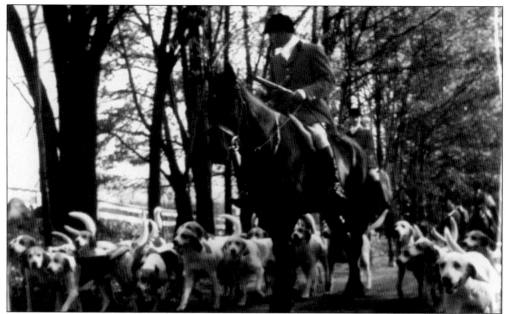

First begun as Grosse Pointe Hunt Club in 1911, the hunt members relocated to Bloomfield in 1914 when development moved in and later to the rolling countryside of Metamora where they became known as Metamora Hunt Club on January 6, 1928. In this photograph, Metamora huntsman Gene Lasher is leading the hounds for the hunt; the hunt members stay a graceful distance away so he and the hounds can work. (Courtesy of Gene Lasher.)

Metamora's foxhunting master Frederick Reynolds is seen here riding up in formal attire. Reynolds is wearing a top hat, usually worn during formal events such as opening day and Thanksgiving. Reynolds was born in Nottingham, England, and moved to Michigan to work at the styling department of Chrysler Corporation as an artist. He did many paintings and illustrations of the hunt members. (Courtesy of the Reynolds family collection.)

Jessie Reynolds was as active member of the Metamora Hunt Club and an accomplished horsewoman. Reynolds's heritage goes back to Scotland: her father was a Stevenson, Robert Louis Stevenson was her great-great-uncle, and her distant ancestors on her mother's and father's sides were the brawling Campbells and McDonalds of the Scotland hills. Her husband, Frederick Reynolds, created this portrait of her. (Courtesy of the Reynolds family collection.)

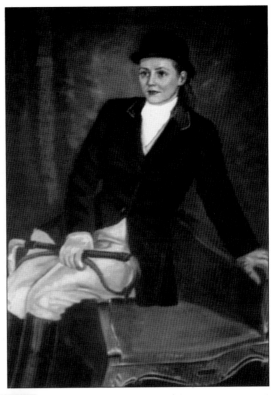

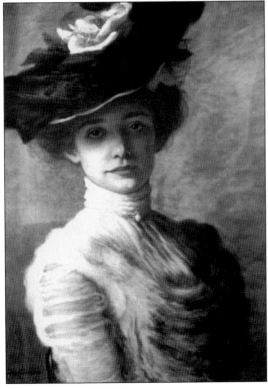

This portrait of Kathleen McGraw Hendrie was done in 1903. She married George Trowbridge Hendrie, former transit executive and member of a prominent Detroit family, in 1906. Kathleen's father owned the Detroit Public Railways. Kathleen and George's favorite sport was foxhunting, and they were charter members of Grosse Pointe, Bloomfield, and Metamora Hunt Clubs. Kathleen and George lost their Bloomfield home during the Great Depression. She gave this painting to Frederick Reynolds to use the canvas to paint on. (Courtesy of the Reynolds family collection.)

Bruno Mosner, an avid foxhunter, was an ex-cavalry soldier in Yugoslavia during the 1940s and owned a large winery business. With the Communist infiltration during World War II, his business, home, and land in Yugoslavia were confiscated. He and his family fled their homeland in 1944 and witnessed the Berlin crisis in 1953. A United States citizen and a successful businessman and property owner, Mosner enjoys the sport of foxhunting on his horse, Appy, in this 1971 picture. (Courtesy of Curtis Middleton.)

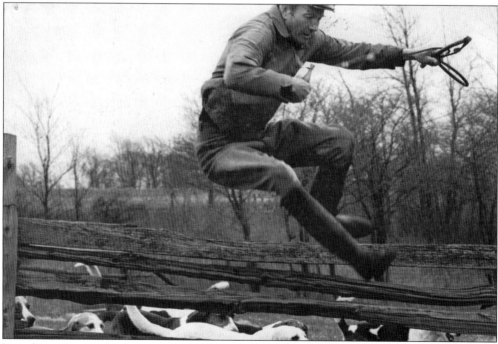

In order to have a fox hunt, one must have a pack of experienced hounds. It is a year-round, seven-days-a-week job, but huntsman Gene Lasher always found a way to put a little fun in the task. Here he is displaying his own talents of jumping. (Courtesy of Gene Lasher.)

110

A hound resembles long-legged beagles with liquid brown eyes and wiggly long tails, with their own markings, personalities, and "voice." The layman would call it "bark," but the huntsman knows when a hound is on the scent of a fox by his voice. The breeding of hounds is according to the land they are hunted upon. For the Metamora countryside, a lighter, faster hound is needed. A hound's lineage can be traced back hundreds of years. (Courtesy of Gene Lasher.)

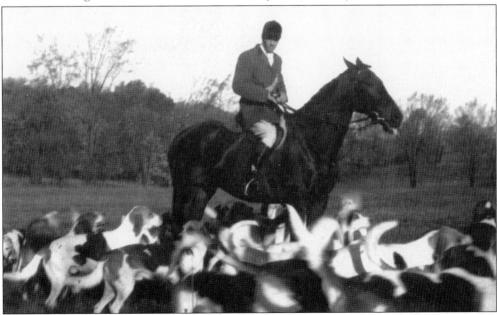

Cubbing takes place from August through mid-September. The a young pup is coupled with an older hound. This is how the older hound teaches the younger to run with the pack. The experienced hound knows the voice and horn commands of the huntsmen and will literally lead the pup onto the proper course. The pup will eventually understand and often respond before the older hound does. (Courtesy of Gene Lasher.)

The term *hacking over* refers to the ride to the spot upon which the foxhunters will congregate to begin the hunt. The hunt usually begins just before daybreak. No rider is allowed to cut across the fields or meadows, for fear they may alert the crafty fox to the coming chase. From left to right, Rosemary Herman, Paul Feehan, and Paul's daughter, Tess Feehan, are the first arrivers. Paul Feehan usually leads the gate group for riders who do not wish to jump the various obstacles that the field may encounter. (Courtesy of Rosemary Herman.)

Started in September 1928, Metamora Hunt Club's opening day usually falls on the third Saturday of September and is a formal event with top hats, scarlet coats, and braided manes and tails. A priest blesses the hounds and a St. Hubert metal is given to every rider. Before every hunt, sherry or orange juice with a biscuit or doughnut will be offered to every participant, a traditional custom of England's hunt decor. (Courtesy of Rosemary Herman.)

In this 1958 picture, even a pending thunderstorm goes unnoticed during the excitement of the hunt. Seen here are huntsman Gene Lasher on Susie's Clock and whipper-ins Curtis Middleton on Kelley and Charles Backus on Jamaica. (Courtesy of Curtis Middleton.)

Oftentimes the hounds will ride to the hunt field. Here the hounds are jumping down from a pickup truck while riders mount their horses for the pending fox hunt on a snowy and frosty morning in 1967. (Courtesy of Curtis Middleton.)

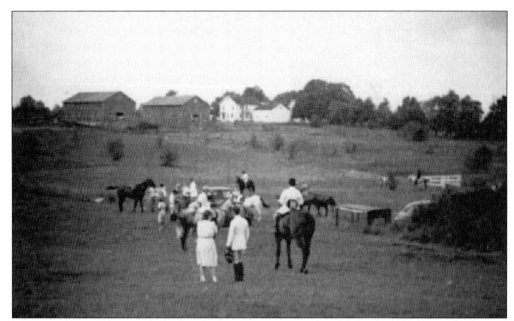

During the hunter trials, club members are judged for their skills in following the hounds, jumping obstacles, and obeying the hunt master. In the background is the tall white building of the Metamora Hunt Club, where many spent afternoons lounging before the fire and enjoying a delicious meal. The club was burned down in the late 1970s, and many historical pictures were lost during the fire. (Courtesy of Jessie Reynolds.)

Competition is important to the avid horse rider. Here are Jerry Howith, Tom Wilson, Charles Backus, and Ben Colman during the 1959 hunter trials event testing their talents in the art of foxhunting according to the strict rules of the sport. (Courtesy of Gene Lasher.)

Huntsman Gene Lasher, riding Pete in 1951 during the hunter trials event, sails over the white fence that looks like it is decorated for an early Christmas with an evergreen garland. (Courtesy of Gene Lasher.)

These two riders are competing in the 1957 hunter trials in the pairs event over a fence consisting of fencing and brush, a typical jump one may encounter during a hunt. Ben Colman is on Colleen and Gene Lasher is on Double Wedding. (Courtesy of Gene Lasher.)

Charlotte Nichols, daughter of Metamora Hunt Club's first master, Elliot Nichols, tries her hand at this impressive stadium jump and looks a little nervous, but she cleans the jump with no trouble. (Courtesy of Jessie Reynolds.)

In this 1960s picture, the White Horse Inn and the Shell across the street are clearly seen on the corner of Dryden and Metamora Roads while Fred Reynolds leads the hunters as they trot boldly down Main Street on their way home. They are all smiles, which can only mean a good time was had by all. (Courtesy of Jessie Reynolds.)

Eight

HILLS

In 1833, Rev. Fr. Lawrence Kilroy arrived in Lapeer to learn if there were any government lands suitable for homes for 10,000 to 12,000 immigrants. He learned, instead, that Catholic priests were not welcome in Lapeer when a group of boys began stoning him. Alvin Nelson Hart immediately came to his rescue and provided him shelter and lodging for the night. Marguerite de Angeli recalls fond memories of Catholic Hill where the old church once stood. It was a perfect sledding hill in the winter months. Perhaps that brief encounter with doctrinal positions and Christian morals became the binding thread toward brotherhood. For though Whitesville is only a memory, just west of Lapeer's downtown business district, where the Presbyterians built their church in 1833 (seen in this picture of 1854), now lies Piety Hill. (Courtesy of the First Presbyterian Church.)

In 1833, the First Presbyterian Church in Lapeer began its service at the house of J. B. Morse and shortly afterward erected this church. The first church building burned down in 1909. However, the congregation erected its present Indiana Limestone building and dedicated it on March 26, 1911, to God, "Thankful for the basic gift of Jesus Christ which does not change." (Courtesy of the Best family collection.)

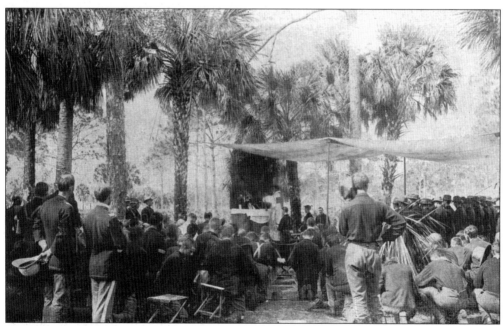

In 1898, during the Spanish-American War, Rev. Fr. Francis Kelly was commissioned as chaplain for the 32nd Michigan Regiment. Upon Reverend Father Kelly's return to Lapeer, he became the guiding light for erecting a church to the "Honor and Glory of God." Reverend Father Kelly became well known for his writings and lectures. *Charred Wood* tells of his life in Lapeer. (Courtesy of the Immaculate Conception Church.)

Dedicated on September 2, 1901, every stone for the Immaculate Conception Church came out of the farms of the parishioners who loaded and hauled them by wagonload to the church site. The Oliver H. Wattles Chime of Bells was placed in the tower of the church, a total of 10 bells with a total weight of 6,198 pounds. The *County Press* wrote, "The Reverend Father Kelley added another to his long list of achievements Monday in the dedication of the Catholic Church." (Courtesy of the LCHS.)

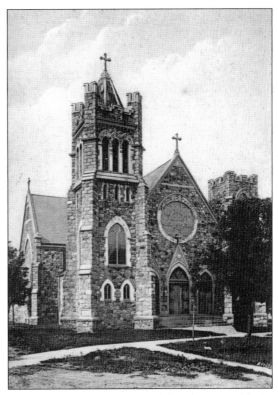

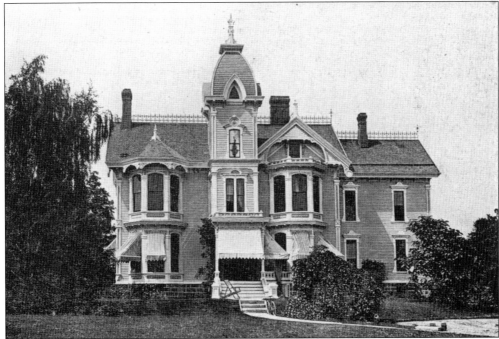

The Ward Jennings home became the rectory for the Immaculate Conception Church in 1900, purchased by Father Kelley for $10,000. It was considered one of the finest homes in town with its beautiful lawn and lovely flowers. (Courtesy of the Immaculate Conception Church.)

Rev. Charles Thorpe attempted to establish an Episcopal church back in 1873; however, his mission in Lapeer lasted a scant two years. This present building located on Nepessing Street was established on September 28, 1881, and the church building was dedicated on April 26, 1882. This church was prominently recognized for its beautiful display of its Queen Anne style of architecture. Membership in the late 1800s was 200 active members with 44 communicants. (Courtesy of the LCHS.)

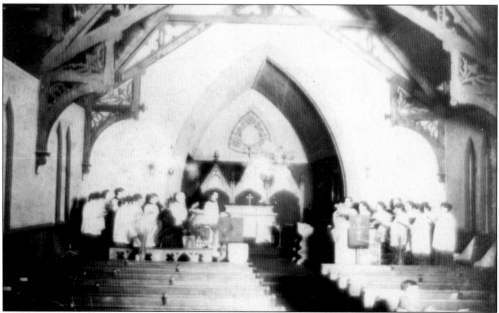

In this early photograph of Lapeer's Grace Episcopal Church, the true beauty of the church's stained-glass windows is hard to see. In the mid-1920s, with the departure of Rev. William Vincent, the parish experienced hard times. Grace Episcopal Church most likely would have dissolved if it was not for the dedication of two men, George Stracke and James Vincent, and 24 determined parishioners. (Courtesy of T. H. Scott and the LCHS, William E. Callis collection.)

"And ye shall hallow the fiftieth year."—Lev. 25:10

MAY 29, 30, 31, 1908
1858 - 1908

Program
of the
Semi=Centennial
Anniversary

FIRST BAPTIST CHURCH
LAPEER, MICHIGAN

KINGMAN NOTT MORRILL, Pastor

The First Baptist Church in Lapeer began in 1858. It was the third church established upon what became known as Piety Hill. This large brick building was erected in 1873 on the corner of Cedar and Law Streets. Its semicentennial anniversary was held on May 29–31, 1908, by Pastor Kingman Nott Morrill. (Courtesy of the LCHS.)

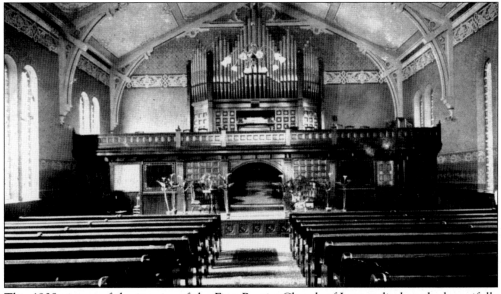

This 1908 picture of the interior of the First Baptist Church of Lapeer displays the beautifully scrolled craftsmanship of this centennial church, which has continued to service the community for over 100 years. (Courtesy of the LCHS.)

This class picture of the First Baptist Church of Lapeer Sunday school includes, from left to right, (front row) unidentified, Arthur Lofft, Eubalia Tuttle, Babe Elliot, Walter Rowden, Donna Williams, and dog Tatters Williams; (second row) Carl Lockwood, unidentified, unidentified, and Eunice Owen; (third row) Glen Owen and Verna, Dan, and Ivan Barber. (Courtesy of the LCHS.)

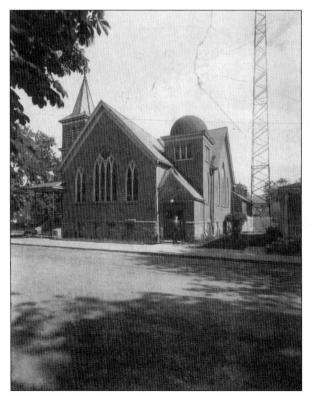

The Methodist Protestant Church of Lapeer was formed in 1844, and the building was later sold and used as the S. D. Brown furniture store. The second Methodist church was built in 1864 and torn down in 1895, and the third church was built upon the present site in 1895. In 1918, 24-year-old Pastor Frank S. Hemingway came to the pulpit as a visiting preacher. Hemingway became the church's pastor and the pioneer of Christian radio. (Courtesy of WMPC.)

With headphones clamped tightly to his ears, Frank S. Hemingway listened to a radio station at a friend's home and imagined the possibility of reaching thousands for Christ. However, in 1926, radio was in its infancy and many parishioners considered this modern gadget "demonist" and thought the church should stay clear of it. Nora Eastman was one such voice. She proposed an all-night prayer vigil, assured that God would prove her accusations just. (Courtesy of WMPC.)

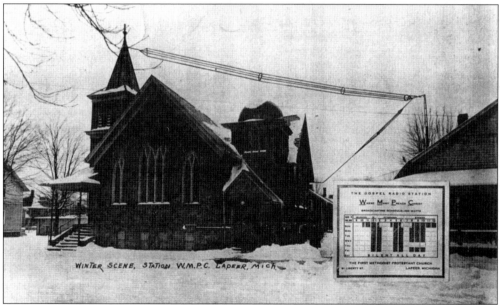

After that all-night prayer vigil, Eastman felt assured that Hemingway's vision was God inspired. This adventure of faith lead Pastor Hemingway to build a radio station after purchasing *The Complete Radio Book* from an encyclopedia salesman. This was a "squirrel cage" apparatus, as seen here. The antenna was made of bicycle rims with wire stretched between the dome of the church and pole with a homemade four-tube, 5-to-50-watt transmitter powered by storage batteries. (Courtesy of WMPC.)

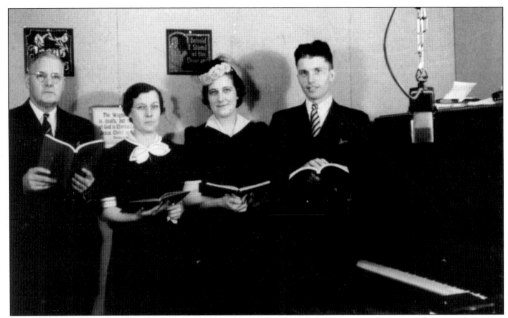

Pastor Frank S. Hemingway's first radio broadcast was December 6, 1926, at 9 p.m., consisting of scripture reading, organ music, singing, and talks to shut-ins. The station broadcast two to three hours a day, six days a week. In this photograph are, from left to right, Ray Moore, Nora Eastman, Beatrice Raduchel, and Elmer Beals singing. Behind them is a plaque that reads, "Behold, I Stand at the Door and Knock." (Courtesy of WMPC.)

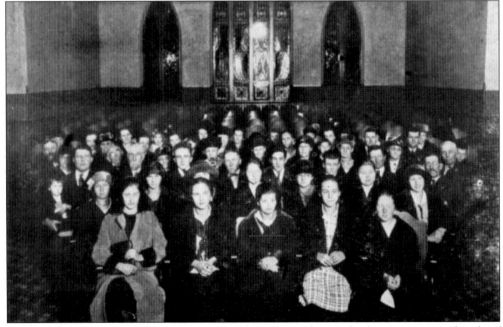

Making WMPC succeed was not an individual effort. The Methodist Protestant Church of Lapeer Bible study class during the 1920s was often called upon for prayer and Bible readings throughout the station broadcasting. Little changed through the years except the Methodist Protestant Church of Lapeer became the Liberty Street Gospel Church. (Courtesy of WMPC.)

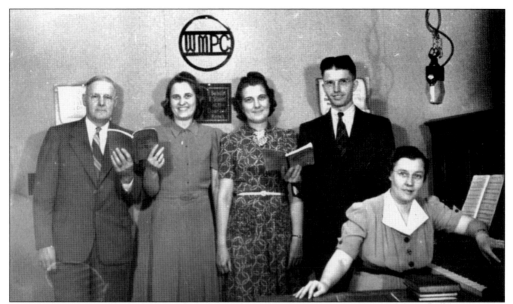

Even the call letters of the station (Where Many Preach Christ, first established for the abbreviation of Methodist Protestant Church) became biblical. Then, and even to this present day, WMPC is recognized as the broadcasting station owned and operated by a church and supported by freewill offerings. In this photograph are, from left to right, Roy Moore, who owned the Lapeer Hardware Store, Adelaide Zemmer (wife of Dr. Harry Zemmer), Beatrice Raduchel Smith, and Elmer Beals, who sang baritone. Nora Eastman is at the piano. (Courtesy of WMPC.)

In August 1930, Hollis Hayes, brother-in-law to Rev. Frank S. Hemingway, became chief engineer and partner in this nonprofit radio station. Hayes was instrumental in keeping the equipment operational and continued to do so until his retirement in 1971. Here he is seen operating the mechanisms. (Courtesy of WMPC.)

In December 1931, a group in Mount Clemens wanted WMPC's license and wave length. They claimed "WMPC was not serving the listening audience," and was not fulfilling the requirements of "public interest, convenience and necessity." Prayer warriors fell to their knees, and Frank S. Hemingway was promised of God's intervention for the work in Isaiah 27:3: "I the Lord do keep it." Congressman Louis C. Cramton did not hesitate to come to their aid, and a grateful congregation sang the praises. (Courtesy of WMPC.)

The dedication of the new building that would house WMPC was in September 1975. Through the course of faithful years, WMPC has broadcast more church programs than any other radio station in North America. (Courtesy of WMPC.)

One Lapeerite said of Reverend Hemingway, "as near a saint as anyone can be without being one." Reverend Hemingway continued to serve the Lord through WMPC ministry until his stroke and subsequent death on July 25, 1965; however, he has handed his vision into the hands of his capable followers to "keep the station on the air until Jesus comes." (Courtesy of WMPC.)

This view of Lapeer during 1904 shows the beginning evolution of Piety Hill. Five churches reach their spiraling steeples toward the heavens: the Immaculate Conception Church and rectory, the Methodist Protestant Church of Lapeer, Grace Episcopal Church, the Methodist Episcopal Church of Lapeer, and the First Presbyterian Church. They would begin the continuing saga of what Lapeerites and later historians would call Piety Hill. The 15.5 acres located west of Lapeer's downtown business district named Piety Hill was officially designated as a historical district in 1984 and consists of 29 19th-century dwellings. (Courtesy of the Immaculate Conception Church.)

ACROSS AMERICA, PEOPLE ARE DISCOVERING SOMETHING WONDERFUL. *THEIR HERITAGE.*

Arcadia Publishing is the leading local history publisher in the United States. With more than 3,000 titles in print and hundreds of new titles released every year, Arcadia has extensive specialized experience chronicling the history of communities and celebrating America's hidden stories, bringing to life the people, places, and events from the past. To discover the history of other communities across the nation, please visit:

www.arcadiapublishing.com

Customized search tools allow you to find regional history books about the town where you grew up, the cities where your friends and family live, the town where your parents met, or even that retirement spot you've been dreaming about.